IMAGES
of America

WHARTON

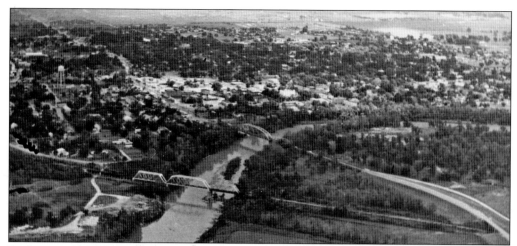

Looking south, this panoramic view of Wharton along the Colorado River shows the town in the early 1900s. Caney Creek and Peach Creek acted as outside borders for the businesses and neighborhoods until they were passed over as the city grew in the later years. Today Wharton stretches in every direction from the river's banks. (Courtesy Wharton County Historical Museum.)

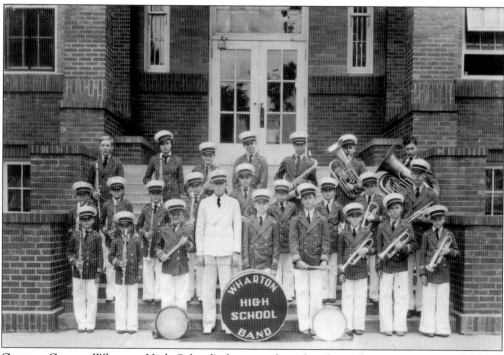

ON THE COVER: Wharton High School's first marching band stands at attention on the high school steps for their yearbook picture. (Courtesy Wharton County Historical Museum.)

IMAGES
of America

WHARTON

Paul N. Spellman

ARCADIA
PUBLISHING

Published by Arcadia Publishing
Charleston SC, Chicago IL, Portsmouth NH, San Francisco CA

Printed in the United States of America

Library of Congress Control Number: 2009943102

For all general information contact Arcadia Publishing at:
Telephone 843-853-2070
Fax 843-853-0044
E-mail sales@arcadiapublishing.com
For customer service and orders:
Toll-Free 1-888-313-2665

Visit us on the Internet at www.arcadiapublishing.com

This book is dedicated to the staff at the Wharton County Historical Museum, and to the citizens of Wharton, past, present, and future.

CONTENTS

ACKNOWLEDGMENTS

This story about the city of Wharton, Texas, could never have been told without the remarkable resources of the Wharton County Historical Museum at 3615 Richmond Road in Wharton. Marvin Albright, the museum's director, and his staff supported the project and encouraged me from start to finish, and I am so grateful for the many original photographs they allowed me to scan and duplicate from the rich files on their shelves. I am especially thankful to researcher Janet Hobizal, on staff at the museum. Janet has painstakingly worked through the thousands of old photographs, and the stories that go with them, indexing and refiling and being so very helpful to me along the way.

Two published resources that proved invaluable guides were the *Wharton County Pictorial History: 1846–1946*, published in 1993 by the county's historical commission and Eakin Press, and Annie Lee Williams's delightful *History of Wharton County: 1846–1961*, published in 1964. Unless otherwise noted, the photographs in this book are courtesy of the wonderful collection of the Wharton County Historical Museum.

I am also grateful to the people of Wharton who have grown excited about this project and delved into their own histories to find resources for me. There are too many to name, but I would acknowledge the members of the Wharton Rotary Club for their particular contributions, including allowing me to speak to their club on occasion and putting me in touch with the city elders, whose stories are so valuable.

And I thank my wife, Kathleen, for her patience in making each winding turn with me on this research adventure and supporting me in every way.

—Paul N. Spellman

INTRODUCTION

Before there was a county named after two brothers, before a town was born, and before the country was populated with roads and rails, the area of the Lower Colorado River Valley came alive every spring with new birth. White-tailed deer roamed the woodlands alongside possum and raccoons, foxes, jackrabbits, and armadillos. Geese, ducks, doves, long-limbed cranes, and clouds of passenger pigeons abounded across the skies above. Bears ruled the forest, wolves the prairies, and rattlesnakes and water moccasins vied with king snakes and copperheads on rocky ground and nearby ponds.

The summer heat withered plant and animal alike, and wild grasses browned but survived at the edge of the live oak and pecan woods. Uninterrupted miles of wild coastal cane 25 feet high and thick as hewn rope grew along the tributaries. In late spring, and often again in the autumn, horrendous floods turned the placid prairies into raging rivers but brought new soil and seeds from the upper valleys to refresh the land. An occasional snow graced the winter, and freezing temperatures came and went quickly.

The first settlers on the Bay Prairie were the Native Americans who sojourned up from the coast (the Coco band of Karankawas) and down the river (the Tonkawas). Although they built no permanent dwellings in this area, these first inhabitants hunted and fished in the abundant region and traded with the itinerant Spanish and French merchants.

But the trails of a Western civilization soon crisscrossed this prairie, and by the early 19th century, people from Missouri, Tennessee, and Alabama began to settle along the Colorado and its tributaries. Towns sprang up, along with farms, ranches, mills, and railways. The frontier moved farther to the west, and the Native American presence of the early decades subsided by the 1840s and vanished a generation later. When the Colorado became navigable for steamboats, commerce flourished farther up the river. Ports at Indianola and Corpus Christi and Galveston provided avenues of trade across the Gulf and to the East Coast.

Wharton was born in 1846 as the result of a mighty effort by dozens of families intent on a permanent site for their children's children to grow and prosper. The county seat grew slowly but steadily into the 20th century, then blossomed for three more generations. Other communities surrounded Wharton, each with distinctive personalities and ambitions. Commerce spread Wharton's prosperity in all directions, and a culture evolved as unique as the people who created it. Two world wars left families on the Bay Prairie victimized but inordinately proud of the service rendered by their lost ones, and the small town spirit continued to evolve.

This is the early story of a community born and bred at the edge of the American frontier, the story of the heritage now proudly shared by the thousands who call Wharton home. These are the people and the places that made Wharton what it is today, the significant events that colored and shaped its culture, and the tumultuous clashes with the same environment that has nurtured this community for 170 years. This is the story of Wharton's beginnings.

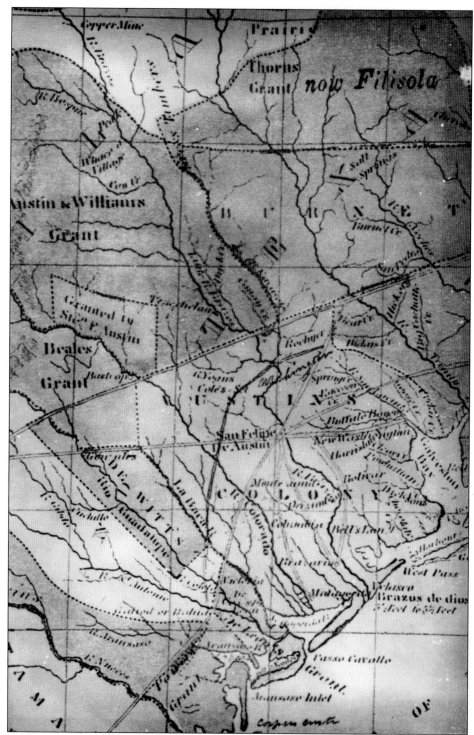

The first *empresario* to bring American settlers into Mexico under contract, Missouri entrepreneur Stephen F. Austin created a model for future colonies that would build around his colony. His maps led settlers to the Colorado River Valley.

One

EXPLORING THE

BAY PRAIRIE

The river valley was home to the Paleo-Indians for 1,000 untold generations, and in the hundreds of years before Euro-American communities were founded, only natives of this land passed through: the Coco band of Karankawas came up from the Gulf Coast to fish, and the Tonkawas traveled down from their villages to the north to hunt bear and deer.

Lost Spaniards made the first contacts with the natives in the early 1500s, and lost French explorers came into this region in the late 17th century. The Spanish later hammered out narrow trails as they connected missions and presidios from the coast inland: the Old Spanish Trail crossed the San Bernard River just to the north. Early Spanish maps of Nuevo Santander and Coahuila, Texas, gave definition to the valley that would soon be home to a new culture—Mexicans and Tejanos. The Texans would claim this land.

But it was the Americans who established the first permanent settlements along the Lower Colorado. They came from the economically panic-stricken Mississippi Valley, led by the Austins as the first *empresarios*. Known as "the Old 300," Austin's frontier families were determined to make something productive out of the hardscrabble land they now called their own. They took on the harsh climate and the defiant American Indians, all for the sake of working the rich, fertile land of the Bay Prairie.

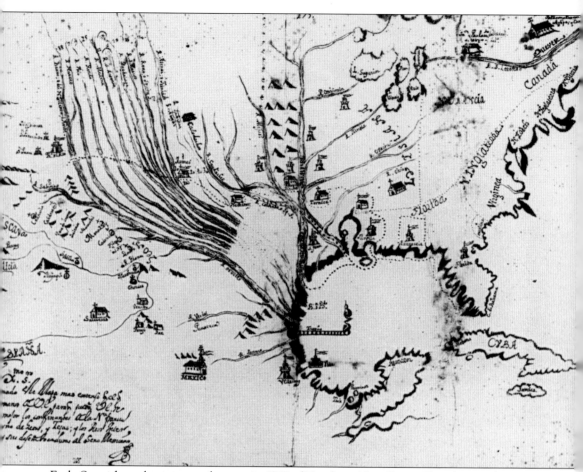

Early Spanish explorers created a map in 1717 of Northern New Spain. Ten thousand years ago, as the last Ice Age warmed and glaciers receded, great rivers gouged out limestone and granite beds as they flowed southwest out of the high hills and spilled into the Gulf of Mexico. The one called *Kanahatino* by the natives, and later misnamed *Colorado* (Spanish for "red") by map makers, measures 600 miles long. The French called it *La Sablonniere*, the "Sand Pit," ignoring its inherent beauty and valuable navigability.

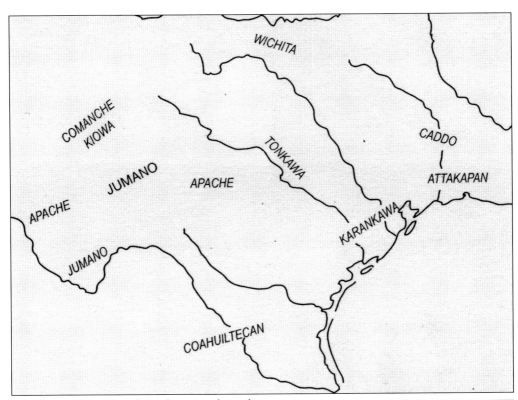

The now-extinct Karankawa language bound several coastal tribes together, including the Cocos, Kohanes, and Copanes. The Cocos, who wandered the mouth of the Colorado River, were primitive residents without permanent housing who survived on fresh water and ocean prey, used spears and long bows and arrows to hunt, and covered their mostly naked bodies with alligator grease to fend off sand flies and mosquitoes.

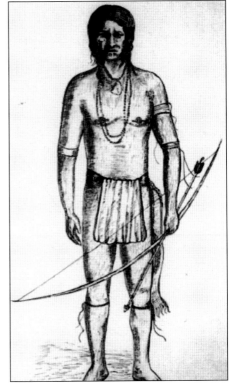

The Kronks built dugout canoes from driftwood but rarely traveled far. Their reputation for cannibalism has been greatly exaggerated over the years, for they seemed in fact to be a harmless people until threatened by the arrival of the European soldiers of fortune. Still there are stories that these Texas natives engaged in atrocities witnessed by early explorers and settlers.

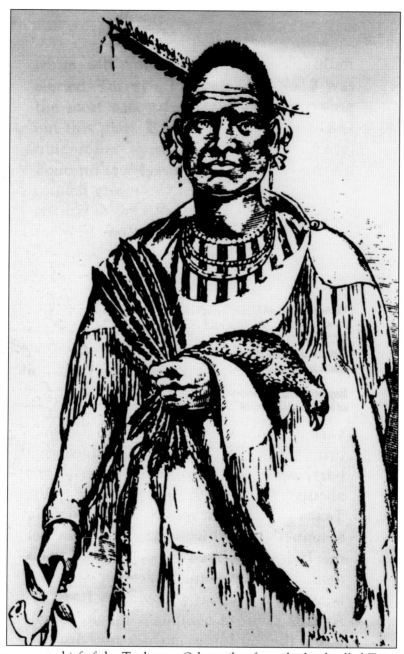

Placido was a great chief of the Tonkawas. Other tribes from the land called Texas may have traveled through the Lower Colorado Valley in search of food, notably the Apaches, Caddos, and Comanches, but it was the Tonkawas from the Brazos River Valley that were more likely to be found hunting deer and bear for meat and hides and gathering pecans for trade. *Tonkawa*, which translates as "all stay together," encompassed several native bands in Central Texas whose origins may have been north in buffalo country and who were somewhat more civilized than the Cocos. Tonkawa bands elected their own chiefs and established firm rituals and ceremonies in a paternal society that emphasized brothers and brothers-in-law as leaders and medicine men. They were enemies of the Apaches and Comanches. (Courtesy Institute of Texan Cultures.)

The first Europeans to walk the land where Wharton would eventually be established were wanderers from a failed Spanish expedition to Florida in the early 1520s. Shipwrecked on Galveston Island, survivors Alvar Nuñez Cabeza De Vaca, pictured here, two soldiers, and a Moroccan servant named Esteban explored the coast of their Karankawa captors, then slipped inland and across the Rio Grande to meet up eventually with Spaniards in northern Mexico. (Courtesy Institute of Texan Cultures.)

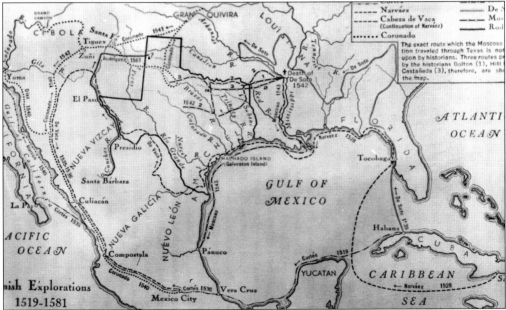

A map of Spanish Texas expeditions (1519–1581) shows routes across the barren land. De Vaca's notes on his remarkable journey gave later explorers and historians valuable information about the Karankawa people and the Colorado River country he passed through. But finding no gold or treasure discouraged further exploration, and distance discouraged settlement. The land that would become Texas was considered a wasteland, unworthy of the *conquistador* expeditions, the last of which moved westward to the upper Rio Grande regions.

René-Robert Cavelier, Sieur de La Salle came to America first as a fur trader. A tragic and lost expedition led by the estimable La Salle, a Frenchman who had previously claimed the majestic Mississippi River Valley for his king, shipwrecked in Matagorda Bay in 1685. A small garrison, Fort St. Louis, was constructed, and La Salle's troops explored the Brazos and Colorado Rivers over the next six months. (Courtesy Institute of Texan Cultures.)

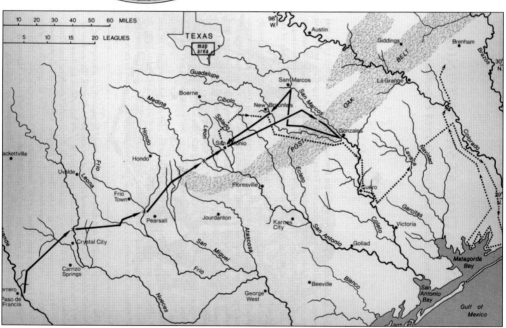

Spanish governor Alonso de Leon happened upon the sad remnants of Fort St. Louis in 1689 while searching for the trespassing French troops now long-since lost or dead. The following year, de Leon led an expedition across the province of Texas, visiting Native American nations, mapping the land, and naming the major rivers. He marked a reddish valley *Colorado*, but a later map mistakenly reversed that and the *Brazos* names, forever branding the two sister river valleys of Central Texas.

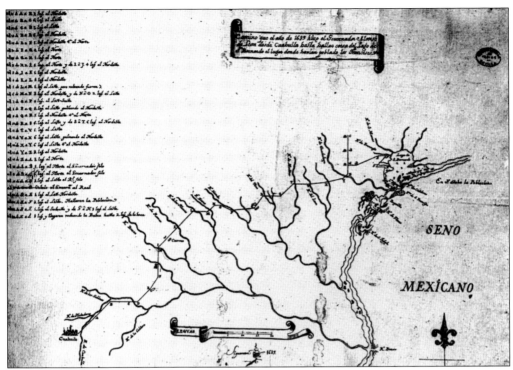

French Louisiana's governor, Antoine de la Mothe Cadillac, agreed with the Spanish to a cooperative trade agreement with the Texas Indian tribes. Cadillac sent the charismatic entrepreneur Capt. Louis Juchereau de St. Denis to close the deal with Spaniard Father Hidalgo. St. Denis made his way from Natchitoches southward to San Juan Bautista in the spring of 1714, crossing the Colorado River near where Wharton stands today.

Five months after founding the Mission de Valero and the *villita* of San Antonio, on September 18, 1718, Spanish governor Martin de Alarçon's expedition, guided by a Tejas Indian scout, arrived on the banks of the Colorado where the town of Wharton would stand 125 years later. They explored the area for six days before heading northwest, recording in a journal that they killed several prairie chickens and two buffalo for food.

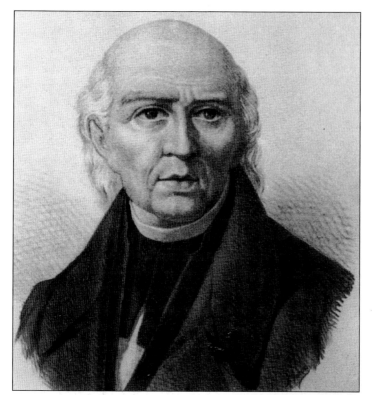

Mexico struggled under Spanish rule throughout the 18th century, culminating in a revolutionary uprising (1810–1821) that brought more bloodshed than liberty for the Mexican people. The revolution's *patron,* Fr. Miguel Hidalgo, pictured here, was killed in the first year of the uprising and became a martyr to the cause of liberty across Mexico.

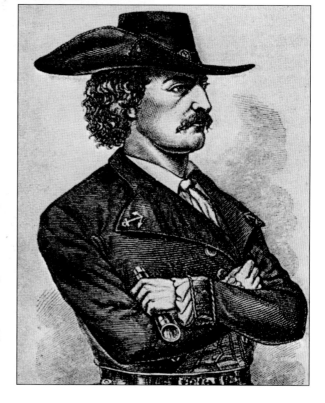

A vacant Texas became the objective of several entrepreneurial Americans during this period of unrest, including men such as Philip Nolan, Jean Lafitte (pictured here), James Wilkinson, and James Long, and armies such as the Gutierrez-Magee Expedition. All were repelled by the Spanish army, leaving a suspicious Mexico with its eye on the ever-restless United States.

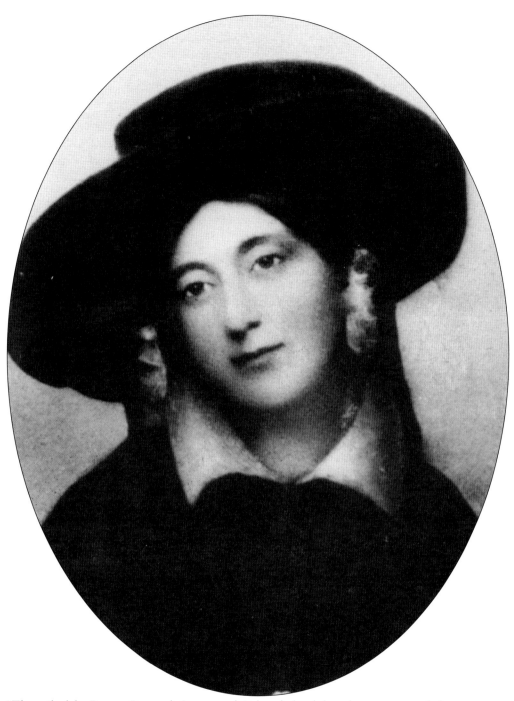

"The soil of the Brazos, Bernard, Caney, and Colorado lands has the same general character as to appearance, fertility, and natural production. It is of a reddish cast, nearly resembling a chocolate color," wrote Mary Austin Holley after her travels across Texas in 1831. "The leaves of the laurel resemble those of a peach tree and is called a wild peach by the colonists. Hence when a colonist wishes to describe his land as first rate, he says 'it is all peach and cane land.'" (Courtesy Center for American History, Austin, Texas.)

Moses Austin, nearly destitute from failed businesses in the American bankers' panic of 1817, came to Spanish Texas to seek a fresh start for himself and hundreds of neighbors, friends, and former business partners. Rebuffed at first by those who thought him just another filibuster, he was eventually granted land to settle 300 colonist families.

Moses Austin died before he could realize his dream, but his son Stephen took up the gauntlet and led hundreds into the land of the Colorado and Brazos Valleys. The newly established Mexican Republic saw great potential in letting eager, industrious Americans work the region heretofore largely ignored as worthless or crawling with nefarious land grabbers.

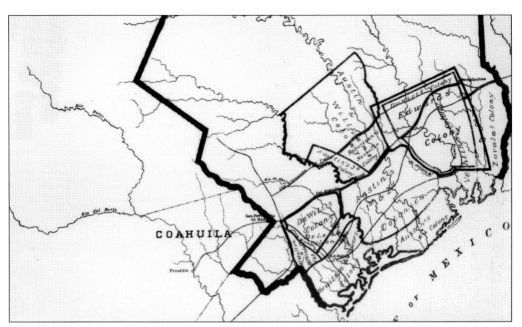

The *empresario* colonies in Texas spread from the Nueces to the Red River. Every settler family in Austin's colony, which stretched from the Gulf Coast 100 miles up the two rivers, received "a league and a labor" of land. This was over 4,600 acres to work tax exempt, and essentially free, as long as the productivity remained high. This first American colony in Texas set the standard for others to come throughout the 1820s.

With the early success of Austin's colony, hundreds of other families made their way to Texas. One of the most successful settlements was that led by Green DeWitt, whose land stood adjacent to Austin south of the Colorado River. DeWitt patterned his colony on Austin's model and often sought his counsel. DeWitt was often seen along the Lower Colorado distributing land for his new settlers.

W. J. E. Heard, an early settler on the Colorado, counted his family among Austin's "Old 300" and settled in the land that would soon become Wharton County with 27 other first families. They hailed from Missouri, Mississippi, Louisiana, and Tennessee. Some of the other early settlers included John C. Clark, John Crownover, Bartlett Sims, James Tumlinson, and brothers William and Joshua Parks.

Jemima Menefee Heard served as matron of her Texas family. One of the most successful early communities was Egypt, settled by the Northingtons, Heards, and Menefees, and so named because of its abundant productivity in this faraway land called Texas. Jemima Heard received a league of land in July 1830 along the Lavaca River, some miles from her son William. John Menefee wrote that after a terrible first year, "there was not much sickness the second season but heavy rains from the time we came."

Thousands of colonists in Texas became disgruntled when the dictator Antonio Lopez de Santa Anna abandoned the liberal constitution of 1824. A wave of rebellion across Mexico in the 1830s resulted in the Mexican army marching to suppress the defiant settlers. "El Presidente" led an army of thousands into Texas in February 1836, intent on brutally suppressing the rebellion.

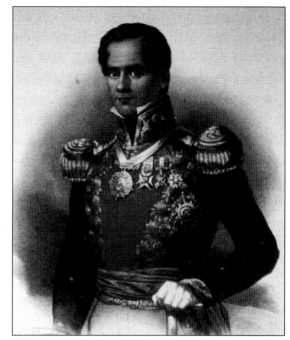

The march against the Texan revolutionaries brought an army from Mexico City to the lower Colorado Valley. Bay Prairie settlers joined the "Runaway Scrape" in March 1836, after the fall of the Alamo and Goliad. The settlement of Spanish Camp was named later for a location on Urrea's march along the coast, which included the conquest of Victoria and Goliad.

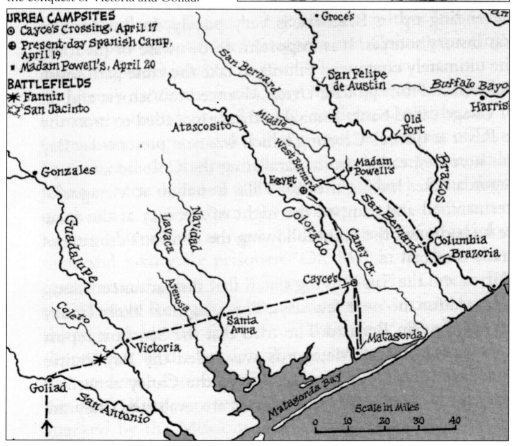

William Harris Wharton (1802–1839) was born in Virginia. Wharton came to Texas with his wife, Sarah Ann Groce, as part of the immense Jared Groce caravan. A hero of the revolution, he served as the Republic of Texas' first minister to the United States and was later captured by and escaped from Mexico. He died tragically when his own gun discharged as he dismounted his horse.

John Austin Wharton (1806–1838), born in Tennessee, came to Texas in 1833 to reunite with his brother William. His heroics at San Jacinto earned him accolades that carried over to the early republic years. He helped organize the Masons in Texas and died prematurely of a fever at only 31 years old.

A drawing of the William Wharton home in Brazoria by Mary Austin Holley was included in her early memoirs of her visits to Texas. The death of the Wharton brothers gave impetus to early settlers on the lower Colorado River to consider the name for their county and town as a memorial to fallen heroes of the revolution.

Three hundred years of exploration, conquest, and settlement of the northern province of Mexico climaxed with the birth of a new nation, the Republic of Texas, in 1836. For a decade, the young nation would struggle to identify its destiny, and finally, it would abandon its independence for the secure benefits of statehood as the 28th state of the United States.

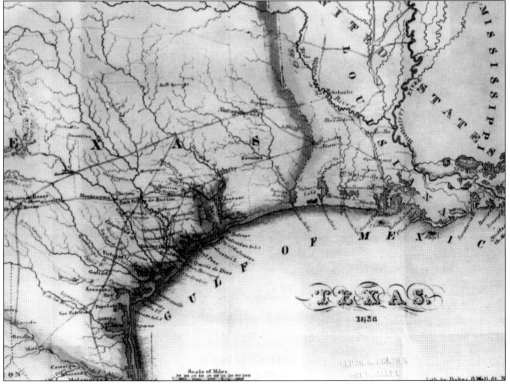

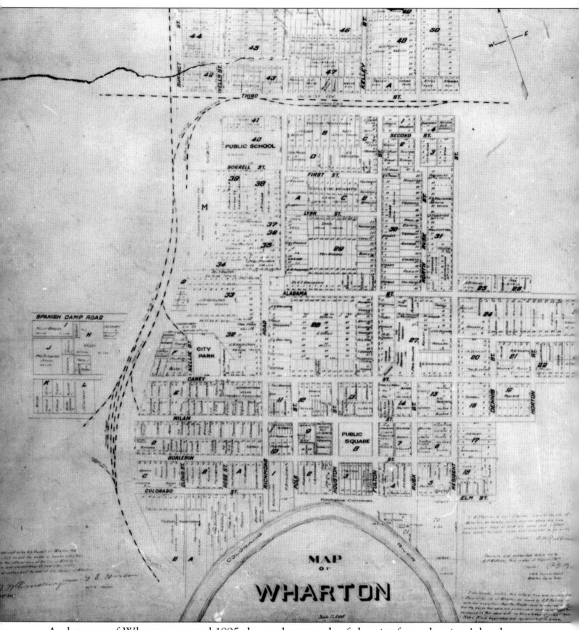

A plat map of Wharton around 1895 shows the growth of the city from the river's banks.

Two

The Alabama Road

As the colony of Col. Stephen F. Austin began to grow in 1823, there were so many families from Alabama that the trail from Indianola and Galveston soon bore that state's name—the Alabama Road. These early settlers worked farms and mills on the Colorado River, the San Bernard River, Peach Creek, and Caney Creek. They grew cane, cotton, and corn and raised cattle, hogs, and goats. They cut the massive trees along the river banks to build homes and barns and then towns. Wildlife was abundant for food, and fresh water was plentiful except in the severest droughts. Later settlers brought slaves from their plantations in the Deep South.

Twenty-seven families of Austin's "Old 300" bought land in what would become Wharton County. Early settlers included Sylvanus Castleman, Robert Kuykendall, A. P. Borden, George W. Singleton, and surveyor Seth Ingram. Eli Mercer ran the first ferry on the Lower Colorado, and William Kincheloe organized defenses against marauding Native Americans.

From 1846 to the 1880s, the small hamlet grew very slowly, surviving the last Native American attacks, the Civil War and Reconstruction, and finally managing to lure European immigrants in large numbers to the region in the 1870s. But it was the railroads that firmly sealed the county seat's future, and the economic growth that followed built a foundation for ensuing generations.

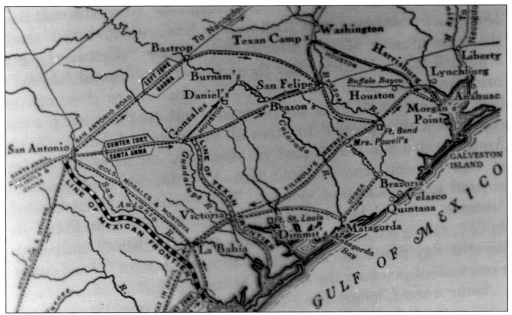

Trails crisscross through the Bay Prairie area. One mile south of present-day Wharton, the tiny Peach Creek community was the first recognized village center in the early 1820s after Egypt, though not incorporated until 1836; two popular river crossings defined the mile-long area. Families along the creek were the Kincheloes, Phillips, and Jacksons. Isham B. Phillips became the first postmaster, Alexander Jackson Jr. ran the first store, William Kincheloe was a blacksmith, and Joseph Bays arrived from North Carolina as the first Baptist preacher in the Lower Colorado Valley.

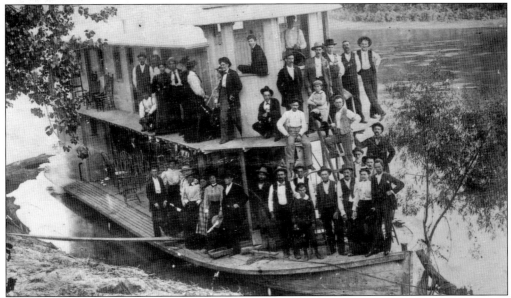

A riverboat, the *Davy Crockett*, docks at the banks of the Colorado River in the 1830s. Early in 1838, Davis Baker, John Huff, and Charles DeMorse promoted a new town on the trail between Matagorda and the Egypt plantations. The town of Preston was operating soon thereafter, proudly claiming a smithy, a general store, and a post office. "The ground is high and perfectly dry," an 1838 advertisement proclaimed, "the water as good as the Republic affords."

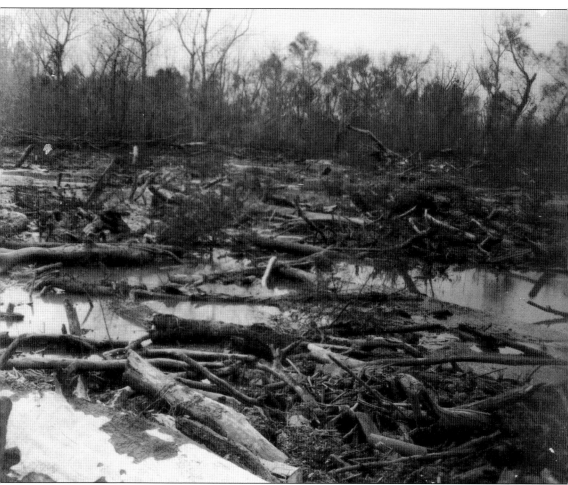

The "raft" of driftwood and debris blocking navigation up the Colorado River from the Gulf Coast proved an obstinate challenge for years. The County of Wharton was established in 1846, carved out of Matagorda, Jackson, and Colorado Counties, and the county seat bearing the same name sits on the east banks of the Colorado, 45 miles from the coast. To become a successful crossroads for commerce, the "raft" had to be destroyed, a project that took decades to complete.

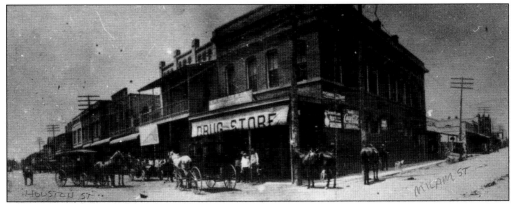

Monterey Square—at Houston and Milam Streets—was simple and bare in its earliest days. Although the county seat did not grow rapidly until the railroads came in the 1880s, there was still a need for a formal courthouse. In 1848, Isaac Hamilton was commissioned to build a structure on Monterey Square, Block 8 of the Wharton survey. Hamilton was beset with financial and construction woes, and it was John P. Carson's plan that became a reality in 1852 at a final cost of $5,200. A pine fence was constructed around the courthouse grounds in 1857.

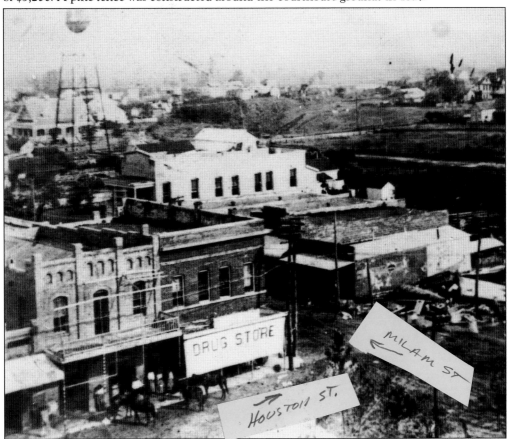

An aerial view of the old courthouse and square shows the spreading town as it heads for the river banks. In 1853, a proposal was made to build a two-story brick and log jailhouse. The final edifice was completed in 1854 at a cost of $5,400. The jail was renovated in 1861.

Architect Eugene T. Heiner from Houston drew up the plans for a new courthouse and jail; the final cost was over $42,000. A compromise was eventually reached, after restraining orders were enforced by the U.S. Marshal's office, to keep the property tax rate at the 1887 level.

The courthouse has withstood more than a century of wear and tear, although it was completely renovated in 1935 and again in 2008. Its iron fence was removed and sold in 1915, and trees were planted on its lawn in 1924. A replica of the original bell tower adorns its top.

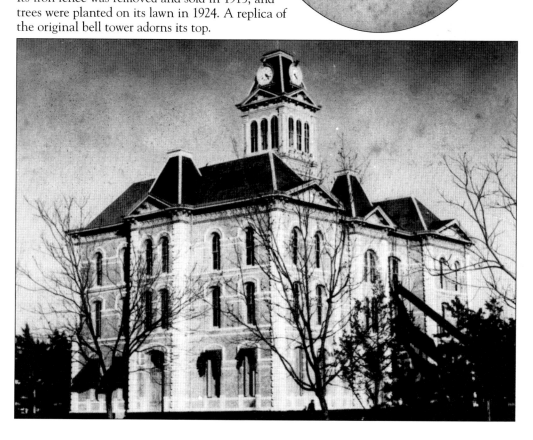

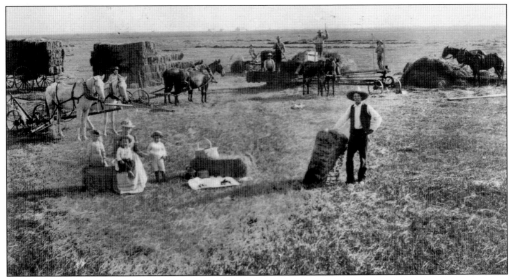

Early settlers enjoy a picnic in their hay field. Farming was the first order of business on the Bay Prairie, and successful planters such as Jared Groce, James Tumlinson, William Pettus, and John Crownover brought their expertise, and often their slaves.

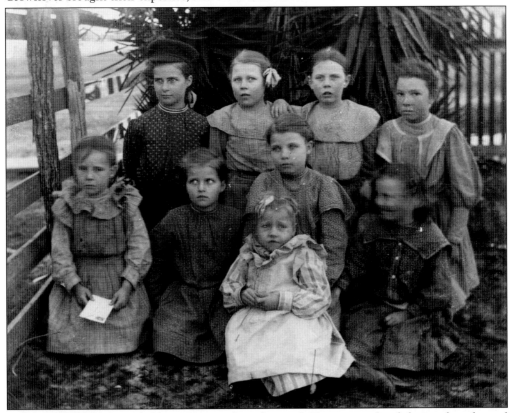

Eight unidentified farm children pose on their dirt yard. Times were hard during drought and flooding, extreme heat, and bitter cold winters. Life on the Bay Prairie demanded only the brave and the strong to persist and survive and, finally, succeed.

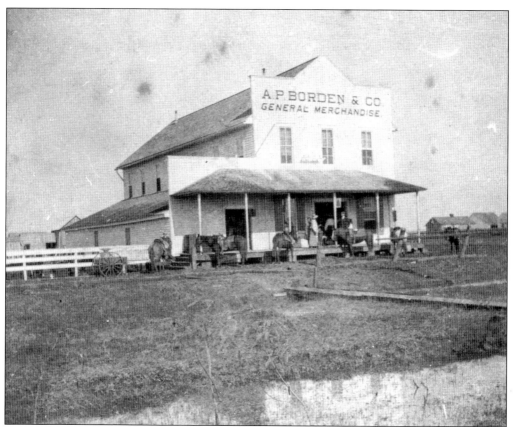

A. P. Borden's mercantile store stood at the center of town in Mackay. The brother of entrepreneur and early settler Gail Borden, Abel Borden bought 1,400 acres of farmland where he later experimented with planting camphor and tea. He later served as postmaster in Pierce.

Capt. W. G. Beard settled on the Bay Prairie with some of the original families. Four of the earliest families to settle successfully on the Bay Prairie were the related Heards, Northingtons, Mercers, and Beards of Egypt. During the Texas Revolution, they provided corn and sugar to the Texas army and hid valuables and stored supplies from the Mexican army when it marched through.

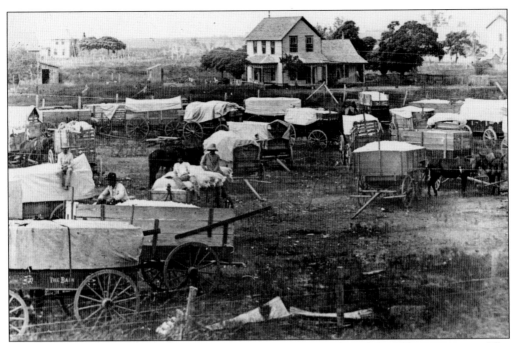

Cotton wagons driven by teamsters and slaves gather at the edge of the Wharton square. The Alabama Road settlers brought the prosperous cotton cash crop with them to Texas, where the climate resulted in abundant crops for most of the next 150 years.

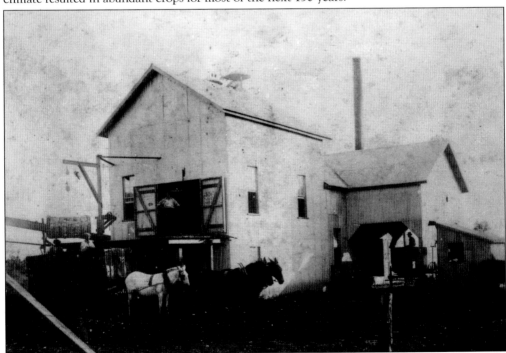

The first cotton gin on the Bay Prairie flourished in Glen Flora. The Bay Prairie cotton plantations produced tens of thousands of bales annually and became major producers for the Confederacy during the Civil War years.

A typical slave contract such as this one can be found on file in the Wharton County records. The 1860 Census recorded 2,711 slaves in Wharton County. A. C. Horton owned 170, R. H. D. Sorrel owned 123, and M. S. Stith owned 118, the three largest slave owners in Wharton.

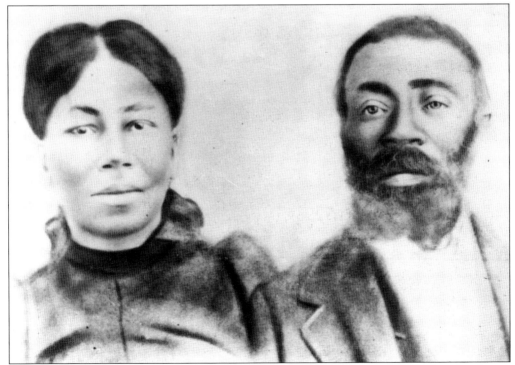

Jane and Henry Harris remembered their early years as Wharton slaves. Fifty-four families in Wharton owned nine or fewer slaves in the 1860s, most of them house servants.

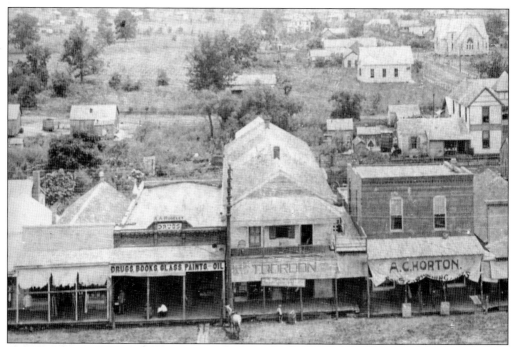

An aerial view of Wharton's town square shows the growth during the Gilded Age. The town of Wharton grew slowly between the 1840s and 1870s but blossomed when the railroads came to Texas.

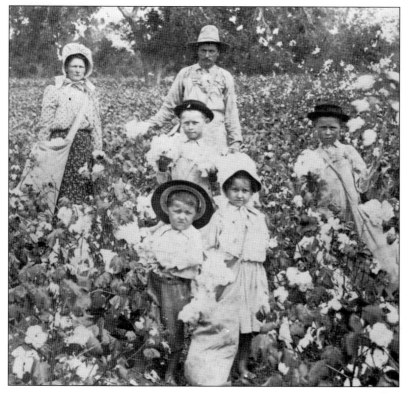

Six people toil in the cotton fields near town. Tenant farms abounded on the Bay Prairie in the years following the Civil War, owned or operated by freedmen and poor white families alike.

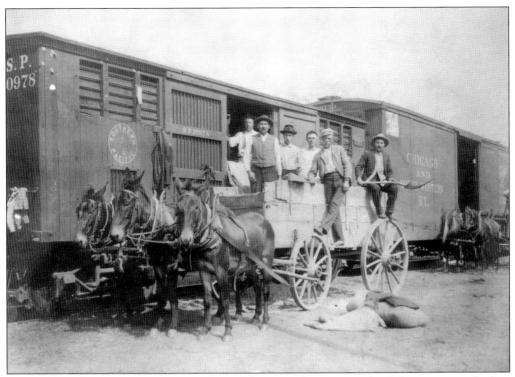

The cottonseed train arrives at the Wharton depot. Mule wagons unload their wares in the late summer days following the cotton harvest and ginning. Millions of dollars came to Wharton for cotton in the latter part of the 1800s.

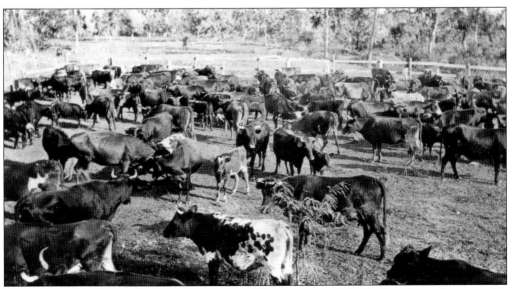

A herd of cattle roams the Rust Ranch near Wharton around 1900. Ranching also proved a successful venture on the Bay Prairie, with hogs, goats, and horses raised along with thousands of head of cattle. The Pierce Ranch brought the first Brahmans to breed in Wharton County.

An alfalfa field in Wharton County stands ready for harvest. Besides cotton, Wharton farms raised sugarcane, hay, corn, rice, and many vegetables for commercial sale. Wealthy agricultural families included Capt. W. J. E. Heard, A. C. Horton, W. F. S. Alexander, and Erasmus Galbraith.

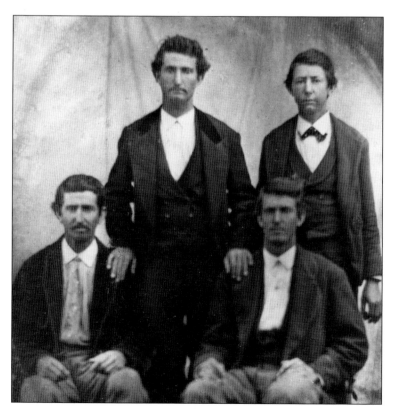

The Hudgins brothers, (from left to right) Green, Alexander, William, and Josiah, characterize the youth and energy of a generation gone by. The Joel D. Hudgins family settled around Hungerford in the 1870s and built a vast estate of farming and ranching in the 19th century. The railroads came through Hungerford, and the Hudgins family became respected community leaders even to the present day.

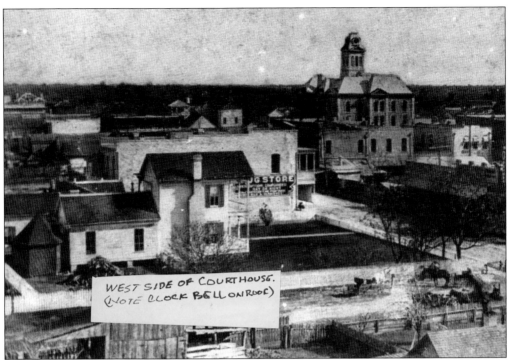

This view of the old Wharton courthouse represents the square in the late 1800s. Virgil Stewart surveyed the town site of Wharton. Stewart, a planter from nearby Brazoria, was married to Lucinda Flowers, a widow who came to the Bay Prairie with 100 slaves and built a home near where the downtown square soon stood.

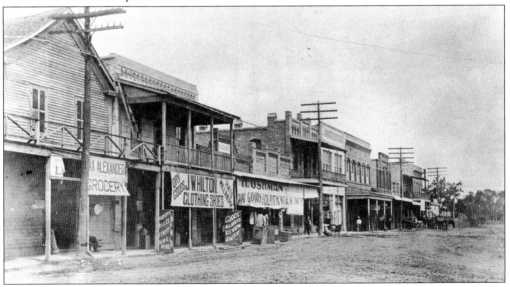

An old street scene across the square belies the wilderness that thrived on the outskirts of Wharton. Black bears and other wildlife roamed the Colorado River banks even after the town was built. Judge J. G. Barbee hosted bear hunts in the area into the 1890s, and residents could hear the bears rummaging through the town's garbage heaps. The last black bear in the town's vicinity was killed in 1926 by Clay Elliott of Glen Flora.

Joe Schattel and his family pose in the 1870s. Immigration to the United States from Germany and Central Europe flourished, especially in Texas. Czechs, Bohemians, Austrians, and many more flocked to the Colorado River Valley. John and Mary Zahradnik were two of the earliest settlers to arrive from Europe.

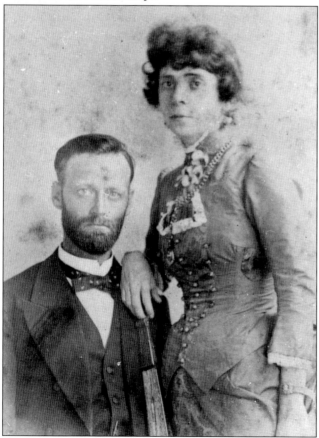

Fred McCamily and his newlywed bride represent many of the early Wharton residents. The schools and churches growing up in and around Wharton included Bohemian names everywhere: Kubes and Jedlicka, Krenek and Macha, Viktorin and Srubar, names still found here today. Louis Martin Strobel settled his family on the Bay Prairie before 1870.

Louis Matusek and his family pose in front of their home in the late 1800s. Organizations such as the Catholic Family Fraternal of Texas (KJZT) and Slavonic Benevolent Order of Texas (SPJST) formed in Wharton as early as 1870 and flourished in the early 1900s.

Joe and Vera Michulka pose with their baby and Agnes Krenek. In nearby East Bernard, Joe Michulka was the first bus driver for the tiny Holy Cross Parochial School. Otto Michulka settled early in the Jones Creek community southeast of Taiton.

Nate Hooker and John Bell express their personalities in the photograph. Young, single men made their way to Wharton to court the daughters of the farmers and ranchers. The Hooker family owned land between Wharton and Boling.

Matej Hejl carries on a rugged frontier life even at age 106. The John Konvicka family came to Texas in the late 1800s, settling in Wharton and on the San Bernard Prairie to the west of town. Hejl, a relative of the Konvickas, was born in the 1820s in Central Europe.

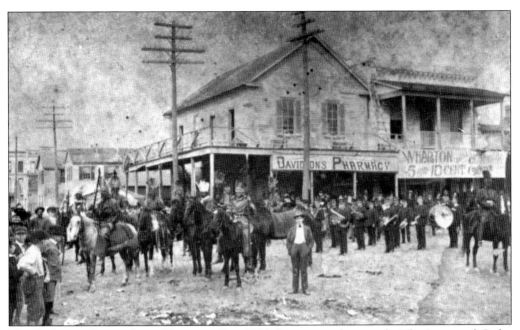

The Redmans Carnival, on Christmas Day 1901, brings out the crowds. The Improved Order of Red Men of Texas, a social and fraternal club descended from the Tammany Hall political organization, was established in Texas in the 1830s. The clubs in El Campo and Wharton sponsored youth activities year-round.

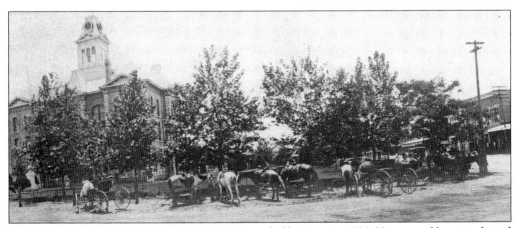

The renovated Wharton courthouse was surrounded by trees in 1901. Horses and buggies dotted the landscape of the Colorado River town before the automobile arrived just prior to World War I. Prior to 1900, a large metal ring stood at the square where horses were tied off by visitors to Wharton.

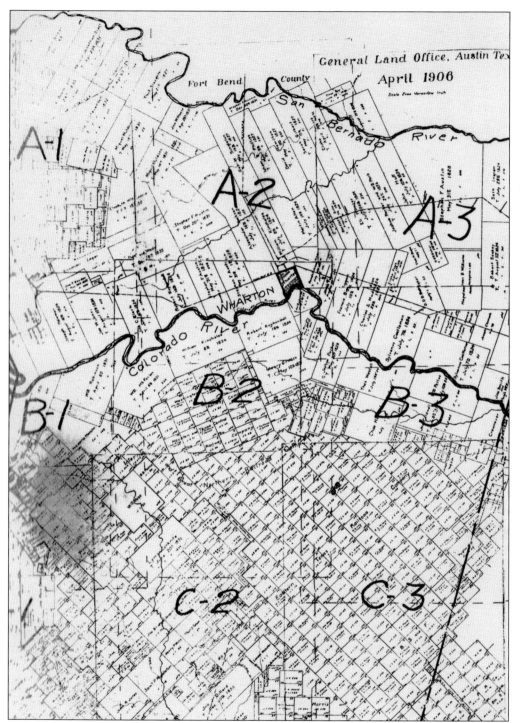

A plat map from the Texas General Land Office, dated 1906, is sprinkled with the small towns growing up on the Bay Prairie.

Three

WHARTON'S CHARMING NEIGHBORS

They are quaint and charming, often beehive-busy, sometimes struggling against the elements or failing industries. They were built around cotton crops or mills, ferries or large ranches. Some grew rapidly at first, but their lights dimmed if the railroad passed them by or a flood sent pieces of them downstream. Others maintained a steady growth over many decades.

The towns of Wharton County that surround the county seat itself offer a delightful peek into the Lower Colorado Valley's past. Some garnered names from settlers or their daughters (Pierce, Louise, and Mackay), while others were named for the beauty that surrounded them (flourishing Egypt and Glen Flora). Spanish Camp actually was one, while the Spanish *El Campo* was another. Tiny Iago suggests Shakespearean inspiration, while Newgulf promoted a more industrialized headquarters. Danevang traces its charming roots to the immigrants who came from across the seas, and curiously, East Bernard sits on the west banks of the river.

Though the city of Wharton boasted a population of only 200 in 1880, that number quadrupled and tripled again when the railroads came through. The 1930 census counted 2,261 souls in Wharton, and that number doubled by 1940, passing the 7,000 mark in the 1960s. The opera house opened in 1888, a library arrived 14 years later, and the first public city park opened in 1913. A junior college landed higher education in the city in 1946.

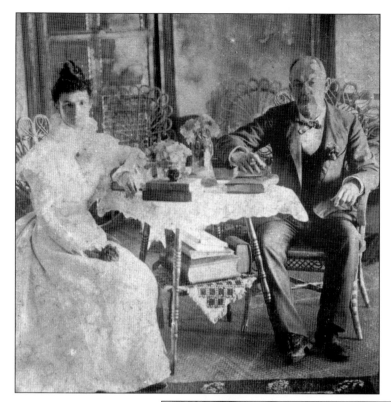

Pictured here are William and Pauline Northington. Egypt got its name from the lush and prosperous land cultivated there by the Heards, Mercers, and Northingtons, and later Green Duncan's Spade Ranch. The Northington "Red Brick Ranch" has been a landmark for over 100 years.

The Beard children were, from left to right, Clarissa, Ella, John, and Will. Egypt boasted a large mercantile store, a gin and mill, and one of the first schools on the Bay Prairie. For generations, the community was the social center of Wharton County, and its history is as rich as its fertile prairie soil.

Glen Flora sprung up from the original land grants of William Kincheloe and Robert Kuykendall, but it was the Scot emigrant William Hood who established the town's name in the 1890s. The Cane Belt Railroad increased interest in the picturesque area.

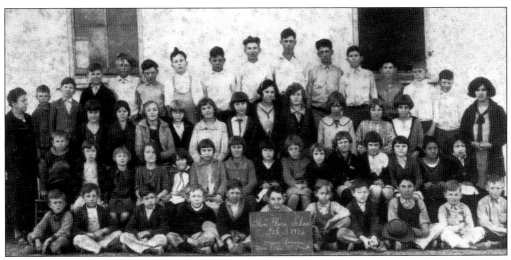

Glen Flora schoolchildren pose on February 26, 1926. The quaint and busy town boasted Hood and Martin's general store, a gristmill, a cotton gin, the first Lutheran church in the region, a fine hotel, and pride in its abundant growth of corn, sugarcane, and tomatoes.

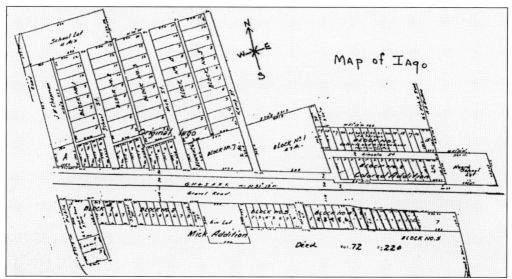

The tiny hamlet of Iago, named after the Shakespearean villain but pronounced "eye-A-go" by most of its citizens, was platted on a section of an original Stephen F. Austin 3/16-league grant by Clarence Kemp in the late 1880s. Kemp also operated a store and the postal station. His son transported the mail by horseback for the first years until the railroads came through the town. G. C. Mick ran a large mercantile store in the early 1900s and gave 2 acres of land for a school to be built. Wharton County sheriff Hamilton B. Dickson lived in Iago.

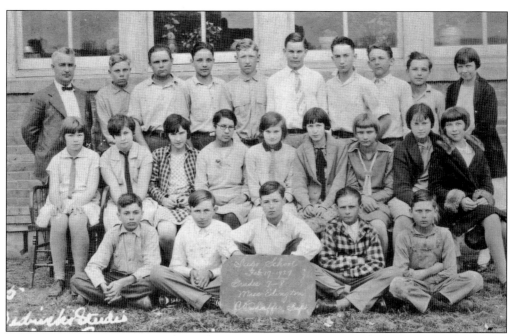

The G. C. Mick family came to Iago in the early 1900s, after the Southern Pacific Railway extended its line thanks to an enterprising appeal by the Iago community. A syrup mill was built there in 1904 by J. R. Embry. The 1927 Iago students pose for their school photograph.

Spanish Camp was an area named following the march of the Mexican army in 1836, and the town was established 40 years later. Legends still abound of Mexican gold buried in the vicinity.

At its peak, the community of Spanish Camp included several dozen families, a cotton gin, and a sawmill. The Hinze brothers became famous for their restaurant and barbecue. But the railroads bypassed the village in the late 1880s, and today, only a highway sign, two churches, and a handful of small farms are left behind.

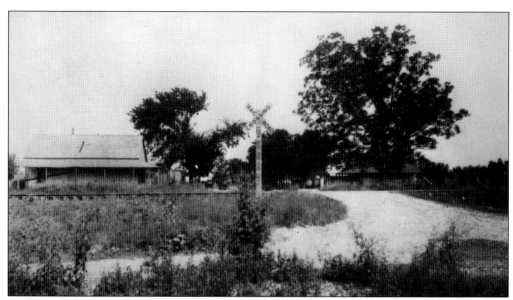

Six Taylor brothers settled Boling in the 1870s near Caney Creek, south of Wharton. Their Don Tol plantation raised corn, cotton, hogs, and cattle, and the main house was a 19-room palace. In 1903, the town was established and named after Mary Bolling Vineyard. (One l was dropped some years later.) Prior to the Civil War, the Taylors owned hundreds of slaves; after the war, much of the work in the fields was done by convict labor. Oil was discovered there in the 1920s, and a company town sprang up in Boling.

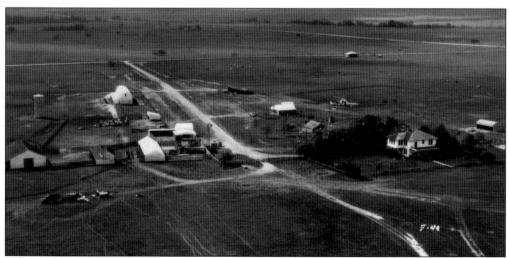

An aerial view of the J. D. Hudgins Ranch near Hungerford shows its expansive boundaries. John W. Mackay and Daniel E. Hungerford helped bring the New York, Texas, and Mexican Railway from Rosenberg to Victoria in 1881. The Hudgins family established businesses and their ranching enterprise in and around Hungerford, where they became internationally famous for the American Grey Brahman cattle breeding operation.

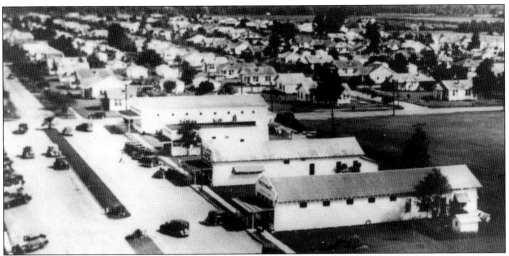

Newgulf came out of the expansion of the sulphur fields in nearby Matagorda County and was established in 1928 for the Texas Gulf Sulphur Company employees and their families. The railroads came there in 1931.

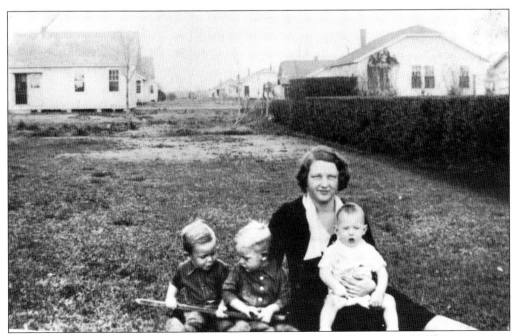

Mary Stringer and her three children picnic on company grounds in Newgulf. The community grew to nearly 2,000 residents by the mid-20th century, and a country club and company picnic ground adorned the area.

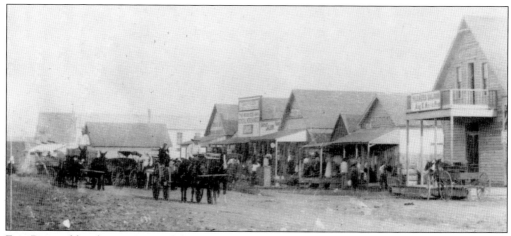

East Bernard has become one of the most significant townships on the west banks of the Lower Colorado River. Originally a war postal station on the east banks—thus its curious name—it was established in 1874. Its location on the railroads and its rich black soil have measured its successful growth for a century.

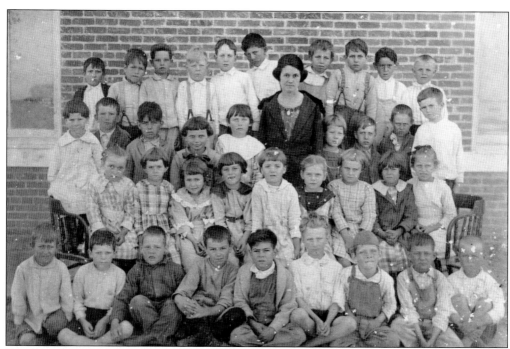

East Bernard first graders pose in 1920. Early names related to East Bernard include Jethro Spivi from Alabama, Uriah Cooper, Haywood P. Stockton, and Louis Pietzsch. Germans and Czechs have a long history growing and expanding that community.

El Campo grows on the "other side" of the Colorado River as "the Pearl of the Prairies," established as Prairie Switch on the railways in 1881. Travelers from across the South and Midwest soon fell in love with the area and returned to live on the fertile land.

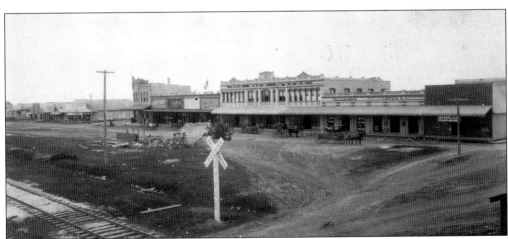

Christian Bruns and the Herman Ranthum family came to El Campo early on; John Norelius and Mack Webb and a number of Swedes soon followed. Andrew Olson's family of 11 arrived in 1895, and the Swedish Methodist Church went up shortly thereafter.

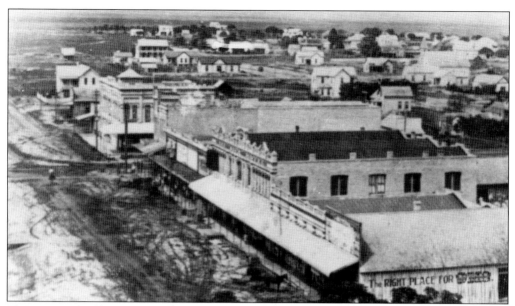

El Campo soon became the second largest, and fastest growing, town in the county, with its competitor, Wharton, across the river and just down the prairie. El Campo boasted a newspaper and 130 businesses by 1900.

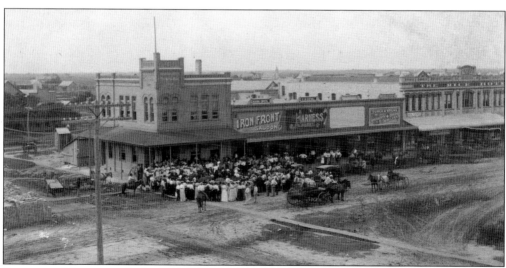

Doctors and lawyers and educators populated the growing town. Cattle and cotton were staples, and a brick and tile works opened in 1909. Floods took their toll on El Campo, like most of the Bay Prairie, resulting in millions of dollars of damage over the decades.

Nearly the whole town turns out for a parade in 1903. The city of El Campo was formally chartered in 1905, and Mack Webb was its first mayor. An ice and water works plant was built there, followed by new schools, a library, and fire department. With a population nearing 10,000 at the end of the 20th century, El Campo is a thriving community with a proud and productive history on the "other side" of the river.

The picturesque little village of Louise was organized in the 1880s as the railroads came through and was named for the daughter of railway president Col. Daniel Hungerford. Its rich soil is especially conducive to the vast rice farming in that area.

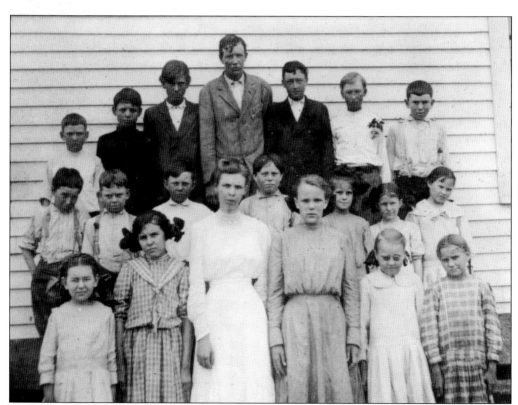

Louise schoolchildren enjoy a 1920 pose. Over the years, Louise citizens have also grown cotton, maize, and cane hay, and oil rigs from the 1930s exploration and cattle ranches abound. G. M. Sadler and Haywood Paul Stockton were two of Louise's earliest promoters.

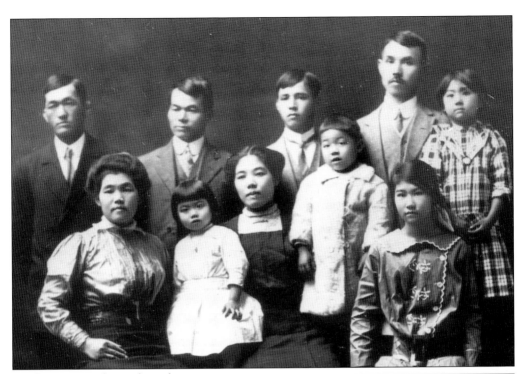

Mackay was another railway depot, established in 1885 by the New York, Texas, and Mexico Railroad and named after Colonel Hungerford's son-in-law. The town site was located on part of the Shanghai Pierce Ranch. A. P. Borden bought up 1,400 acres around Mackay and opened a thriving mercantile store. The Onishi family pictured here worked the rice fields in the area.

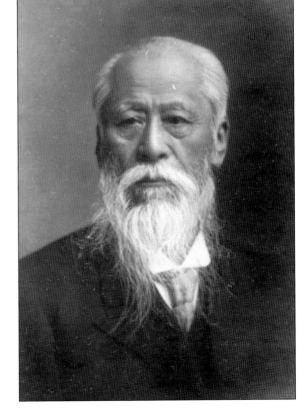

Banker Baron Ichizaemon Morimura IV (1854–1919), founder of Noritake Inc., invested in the Japanese farms he visited near Mackay in 1909. Japanese families like the Onishis and Kagawas, and Russian laborers as well, moved to Mackay to work the tea and rice farms.

The town of Pierce was established in 1881 on the ranch of the celebrated cowboy A. H. "Shanghai" Pierce (1834–1900). Pierce was unsuccessful in his bid to make his town the county seat, but he did manage to build a famous three-story hotel on the square.

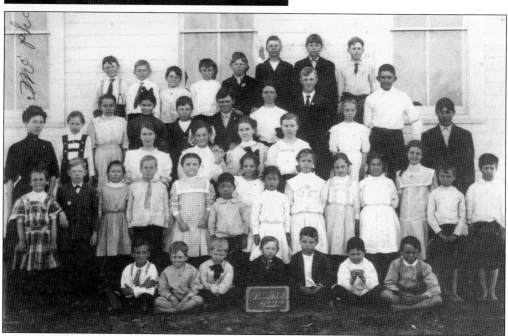

Pierce schoolchildren are pictured here in 1910. Cattle and oil characterize the area today: the first Brahman herd in the United States was imported to the Pierce Ranch around 1900, and the famous Pierce empire included banks and railroads as well. Abel P. Borden was the town's other most famous resident.

The Ladies Aid Society organizes for a community affair in 1902. Danevang is unusual in that its original families and their descendants have continued a rich and self-sustaining Danish culture for over 110 years. Two factions of Danes, the Gruntvigians and the Inner Mission people, settled the town in 1897.

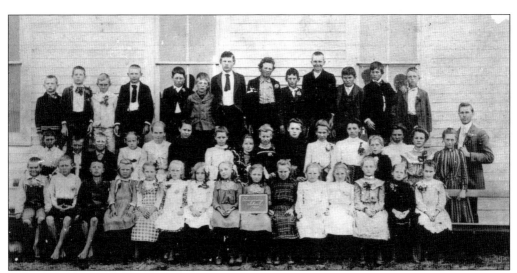

The Danevang School student body looked like this in 1902. Most families came first from Danish settlements in Nebraska and Iowa. Danevang proudly continues its rich Danish culture today and has developed a farming cooperative over five generations that is a model for other successful communities around the country.

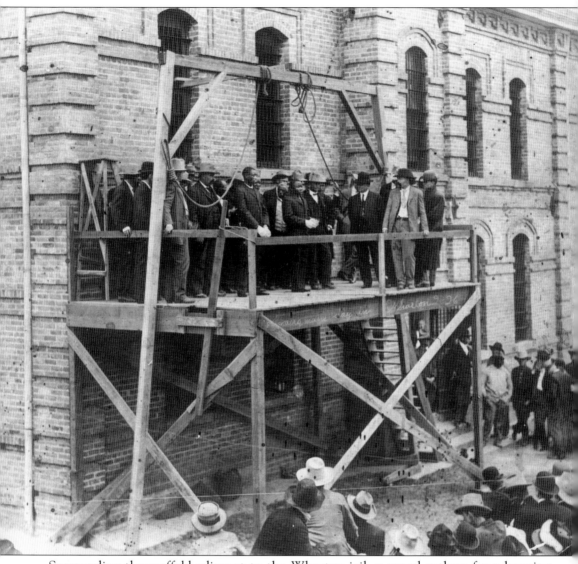

Surrounding the scaffold adjacent to the Wharton jail, a crowd gathers for a hanging around 1910.

Four

Law and Order, War and Peace

"The gun, the whip, and the noose were the three most popular methods of punishment in Wharton." So writes Annie Lee Williams in *A History of Wharton County: 1846–1961*. In the early days, roaming bands of Comanches or Tonkawas often frightened the Lower Colorado Valley citizens, but their damage was slight compared to other areas to the north and west. Sheriffs came and went to keep an uneasy peace when the Texas Rangers were not around, which was often. During Reconstruction, following the Civil War, Wharton, like most of Texas and the Deep South, was fraught with violence and disorder, and beatings and lynchings were commonplace.

Three of the most notorious killings in Texas history occurred in the Wharton area: Tod Fitzgerald's murder of retribution in 1889, Hope Adams's murder tangled up in the violent politics of the day, and the blood feud slaughter of the Crocker family in 1895.

The Ku Klux Klan roamed the Colorado and Brazos prairies in the 1870s and again in the early 1920s. Bonnie and Clyde drove to the outskirts of town in 1930 but escaped a roadblock set up by Sheriff J. C. Willis by the river road. The first jailhouse in Wharton was built in 1854 by Sheriff R. E. Davis, overhauled in 1861, and rebuilt in 1889. A scaffold was erected between the jail and the river banks, and public hangings continued until 1915. A three-story jail went up in 1936 and still stands as an office building.

Two world wars in the 20th century took young Wharton men off to the raging French and Belgian battlefields, and some did not return. Others came home adorned with hard-earned medals of valor. Buildings on the Wharton Fairgrounds became temporary holding camps for German war prisoners in late 1944. Wharton has worn its contributions to freedom proudly over the decades.

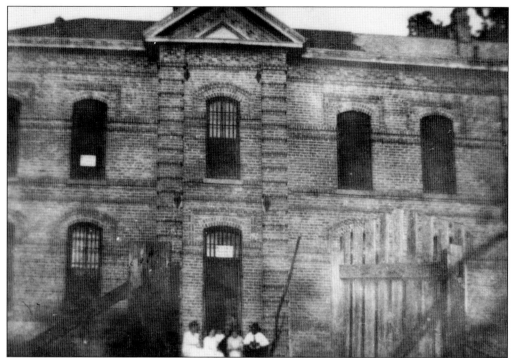

Marshal W. W. Pitman stands in front of the Wharton jailhouse. The first jailhouse in Wharton went up in 1854 under the supervision of Sheriff R. E. Davis. The two-story structure had 8-inch-thick log walls and iron bars half an inch thick and 2 inches wide. In 1888, the county rebuilt the jail at the same time it renovated the courthouse.

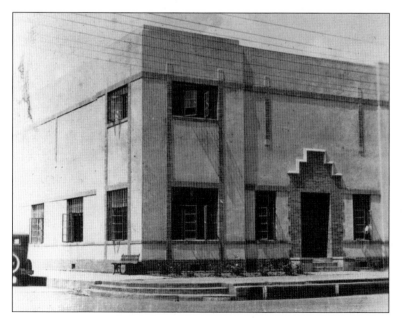

Pictured here is the exterior of Wharton city hall in 1932. The sheriff kept his office downstairs in this building, convenient walking distance from the jail and the courthouse. The hanging scaffold was just across the street in the early 1900s but gone after 1915.

John W. Jones was first elected sheriff in 1886 and served four years, bringing some stability to Wharton law enforcement. He succeeded A. S. Jones, who had been Wharton's sixth sheriff in four years.

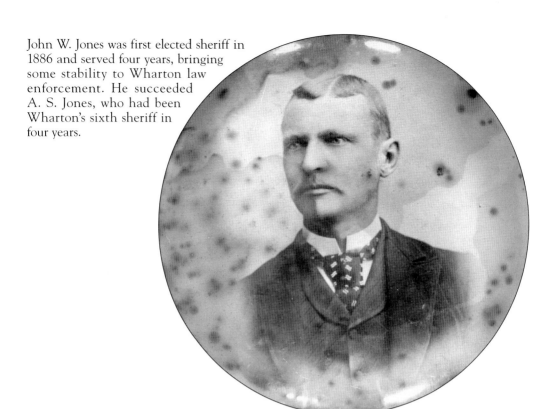

Sheriff Hamilton B. Dickson was elected in 1890 and again in 1892. On a hunt with the Colorado County sheriff Light Townsend in February 1894 for fugitive Dee Braddock, Dickson was killed in a dramatic shoot-out along the Colorado River near Egypt. Eight hundred citizens turned out for his funeral.

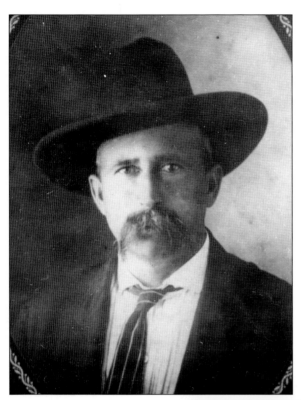

Sheriff Rabb A. Rich succeeded Dickson, although there was a brief appointment in between of Covey Hughes. Rich served four years as sheriff, then one more from 1904 until his death in August 1905.

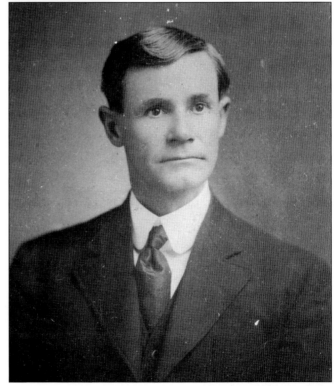

Sheriff Frank Barrett Davis (1857–1912) served two terms in Wharton from 1898 to 1902. Davis's family came from South Carolina by way of Alabama, and Frank and his sister, Maggie, lived on the 1,800-acre family ranch for most of their lives.

Sheriff Robert Koehl (1866–1920) was one of the longest-tenured constables in Wharton, serving from 1905 until 1914. Koehl was born in Ellinger, up the river from Wharton. He became sheriff in August 1905 upon the death of Sheriff Rabb Rich and then was elected for four more terms.

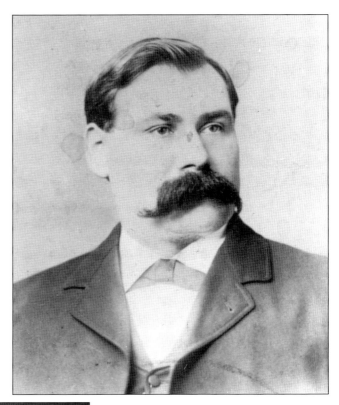

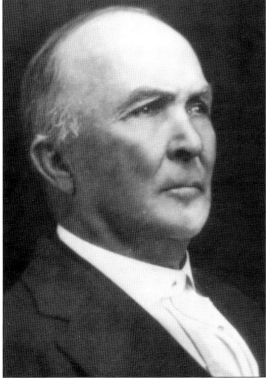

Sheriff Clarence Delano Kemp (1852–1937) followed Koehl and served eight years himself, through 1922. Kemp was from Louisiana and moved to the community that was soon named Iago. Over the years, he owned a ranch, a cotton gin, and a store in Van Vleck and was a partner of Hamilton Dickson in the earlier years.

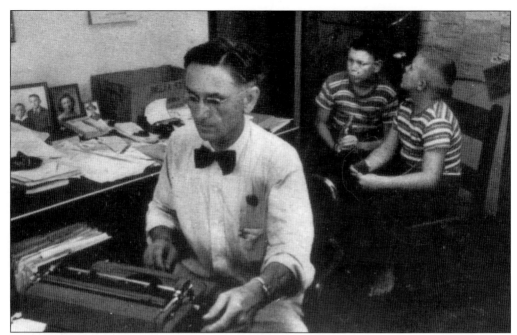

T. W. "Buckshot" Lane was perhaps the most celebrated of the sheriffs who served Wharton in its first century. He was elected to the office in 1940, when he was 37, and was reelected for five more terms.

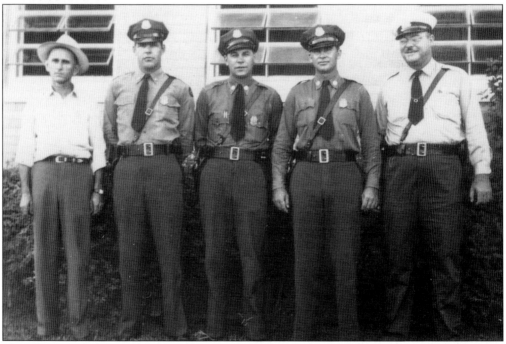

Sheriff Lane stands proudly with four of his deputies. Lane used to tell the story of being arrested by federal agents who thought he was Clyde Barrow. He had a harrowing shoot-out with an escaping felon named Pete Norris on Christmas Day 1945. Lane was wounded in the jailhouse tussle, and a deputy killed Norris.

MIKE FLOURNOY

"Buckshot" Lane strikes a familiar pose. Lane loved the limelight and was always willing and eager to do interviews with the press. He was born and raised in Matagorda County, Texas, and married Margaret McDent in 1932.

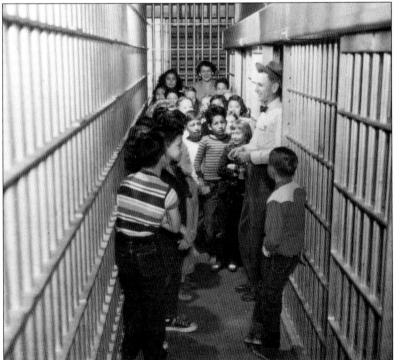

Sheriff Lane talks with visiting students in the jail. After serving as sheriff for 10 years and one month, Lane was elected to the statehouse in 1954 and then ran unsuccessfully for a seat in Congress.

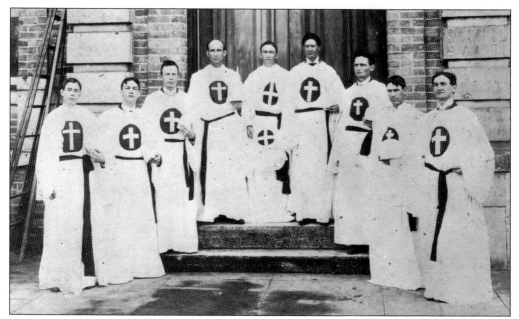

The Ku Klux Klan poses on the steps of the Wharton courthouse in 1908. The Wharton chapter was named in memory of Sheriff H. B. Dickson, who had been killed in the line of duty. Chapters of the White Man's Union and the Knights of the Golden Circle also met in Wharton.

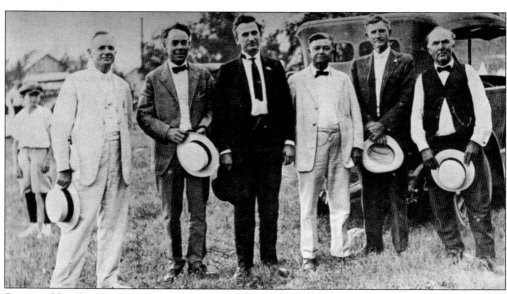

State and local officials pause in their conversation for a 1922 photograph at the Wharton Fair. From left to right are H. E. Wilson, F. W. Shannon, Gov. Pat Neff, state senator W. L. Hall, county judge W. G. Davis, and Sheriff C. D. Kemp.

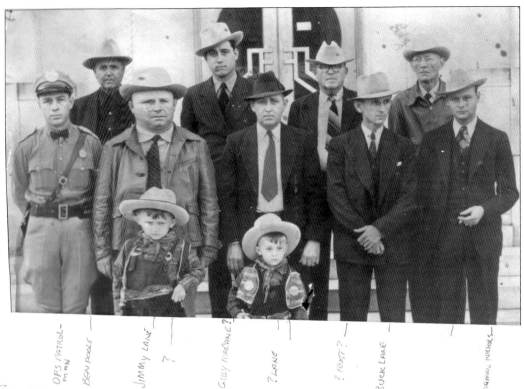

DPS PATROL-MAN | BEN POOLE | JIMMY LANE | ? | GILLY MACLANE ? | ? LANE | ? RUST ? | BUCK LANE | WHAMMY NICHOLS

Wharton County law enforcement in the early 1950s is humorously complemented with two "junior deputies." Long-standing officials of the 1950s included county judge Dorman Nickels, attorney Lloyd Rust, Sheriff H. R. Flournoy, and county commissioners Pete Nelson, Claude B. Dill, Paul Sablatura, and J. G. McDaniel.

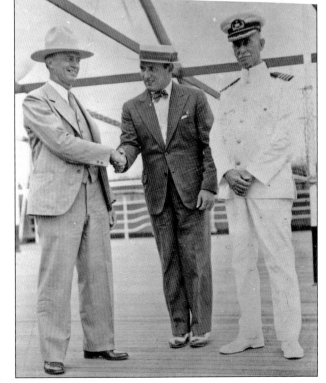

Wharton constable W. W. Pitman (left) poses with Robert Ripley of "Believe It or Not" fame on a prizewinning cruise to Cuba. In a September 1917 shoot-out in downtown Wharton, a felon's bullet lodged inside Pitman's pistol barrel, saving the constable's life and later getting Ripley's attention.

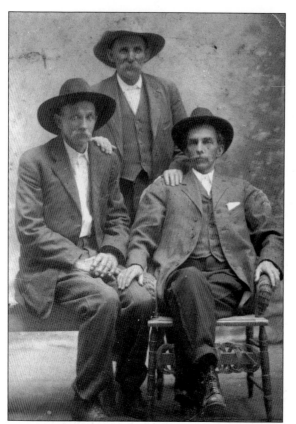

Old judge Wiley J. Croom (standing) poses with two cronies. Judge Croom served Wharton from 1886 through 1890 and was involved in a controversial issue surrounding the rebuilding of the courthouse on the town square. In his later years, he was a bank vice president and an alderman in Wharton. He and his wife, Marienne, were active in civic affairs for years.

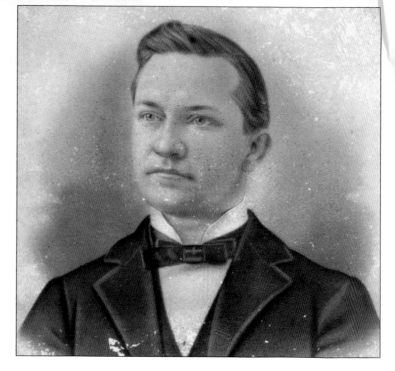

W. G. Davis served as mayor of Wharton (1902–1904), county commissioner (1904–1914), and county judge (1914–1924). Davis settled near Louise in 1891, ran a ranch and a pumping plant, and was a manager of the Louise State Bank.

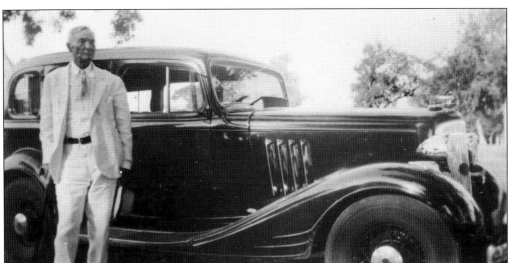

Judge G. G. Kelley poses next to his automobile in 1934 (above) and with his driver, Archie Wheeler (right). Kelley (1859–1938) struck a large and imposing figure in Wharton, especially during the World War I years with his avid and public support of the local war effort. He helped organize the Wharton County Woman Power food drive in 1917 and gave a famous patriotic speech at the 1918 dedication of Blum Air Field, "excoriating the slackers, particularly those who did not subscribe to the Liberty Loan."

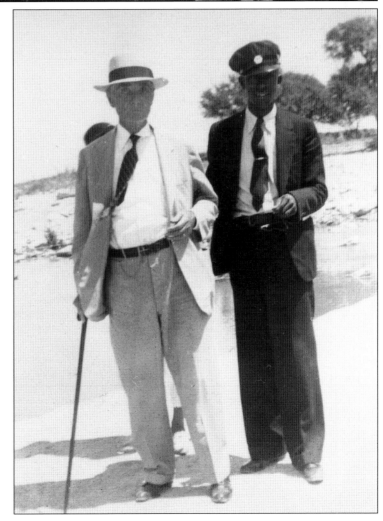

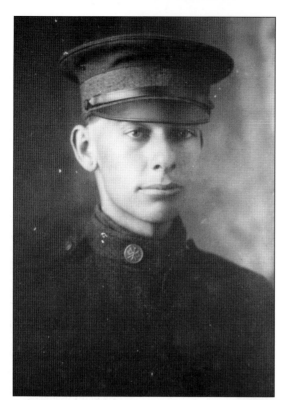

Robert Lee Roten stands at attention in a World War I uniform in 1918. Roten, whose family was in the mercantile business in Wharton and El Campo, enlisted on December 10, 1917, served in the 194th Aerial Squad at Ellington Field, and was discharged as a sergeant on July 2, 1918. Company B of the 5th Texas Regiment was the first to muster in Wharton County on Labor Day 1917.

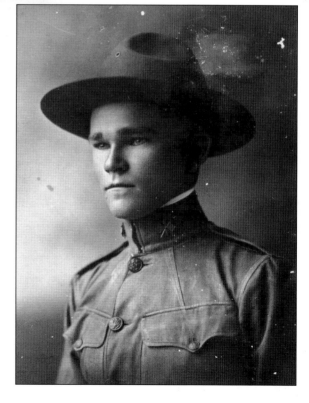

Sgt. Maj. Travis Smith of Wharton served his country from April 6, 1918, through the end of the war and continued in postwar service until his honorable discharge on November 20, 1919. In a 10-week period during the 1918 Argonne Offensive in France, six soldiers from the Wharton area died in battle, including army captain Sam Craig (September 14) and Sgt. Alvin Rodgers (August 6).

Howard Davidson (left) poses outside his home in 1918 with his mother and an army buddy. There were 1,115 men enlisted in the armed services from Wharton County between 1916 and 1918, including 68 African Americans who served overseas.

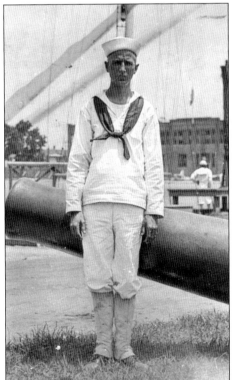

J. Van Leeds Sr. of the U.S. Navy (1918) was one of 71 Wharton boys who chose the navy as their branch of service. All of the sailors came home alive at the end of the war. There were 20 who served in the U.S. Marines, including Cpl. Horace Enus Rowold, who died in battle in July 1918 and was posthumously awarded the Medal Militaire and the Croix de Guerre.

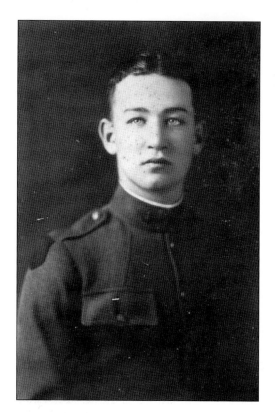

Bill Cline appears in uniform in 1918. Henry and Elizabeth Cline's son, Bill served in the army in 1918 alongside many of his boyhood friends, including Elo Franke, Henry Hillyard, Spencer Rowan, and Ben Miller.

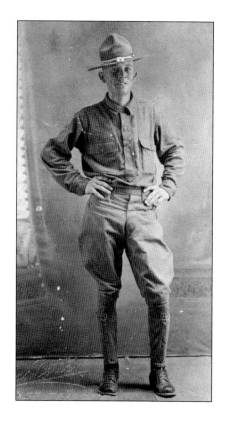

James Q. "Kid" Heard prepares to go off to war in 1918. The Heard family contributed its young men and women to five wars between 1850 and 1950. Kid Heard became famous as a local rodeo bull rider and roper. Brothers Sam and Tom Heard served as Texas Rangers in the early 1900s.

Capt. Frank Jiggs Maerz and Marion Kleas Maerz make a typical war couple in this 1943 photograph. Frank Maerz entered World War II in 1942 as a second lieutenant and quickly rose through the ranks. Thousands of Wharton men and women served bravely in World War II, many of them giving the ultimate sacrifice for their country.

Robert Dayvault Williams of the U.S. Army Air Corps gained fame as an ace for his air combat exploits over France. Williams grew up in nearby Glen Flora, and 26 of his boyhood friends served in the war. One of those soldiers, Ed Anton Riha Jr., was killed in action overseas.

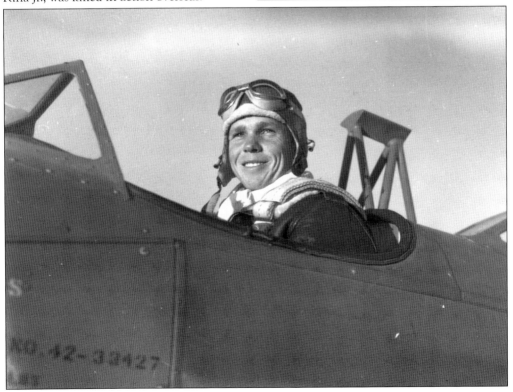

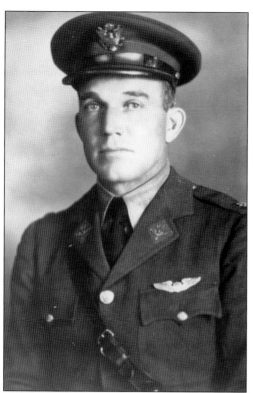

Although Maj. Gen. Howard C. Davidson of the U.S. Air Force returned home safely after the end of the war, 36 Wharton men were casualties of that war. Fourteen became prisoners of war, and two died while being held by the Germans.

Wharton men stand tall as part of their Defense Guard, 147th Battalion in September 1943. A number of Wharton men headed overseas early on; Ben Freeman Mays enlisted in the British Royal Air Force in 1941 and was shot down over Germany in April 1942. The first Wharton casualty of World War II, Mays's name adorns the local American Legion Post No. 87 along with Enus Rowold.

The fairgrounds buildings on Alabama Road and Boling Highway served many purposes over the years. In the fall of 1944, hundreds of German prisoners of war were being moved to holding camps around the country. The Wharton fairgrounds became one of those holding camps, and many of the German POWs worked under supervision to bring in the fall crops in the area. The community of Wharton made great contributions to the war effort, including the service of women in the Red Cross and as army nurses. The area Red Cross headquarters were on Elm Street.

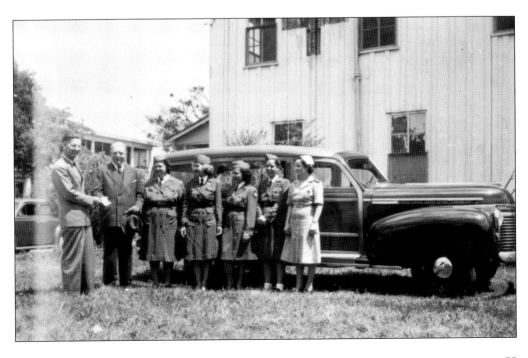

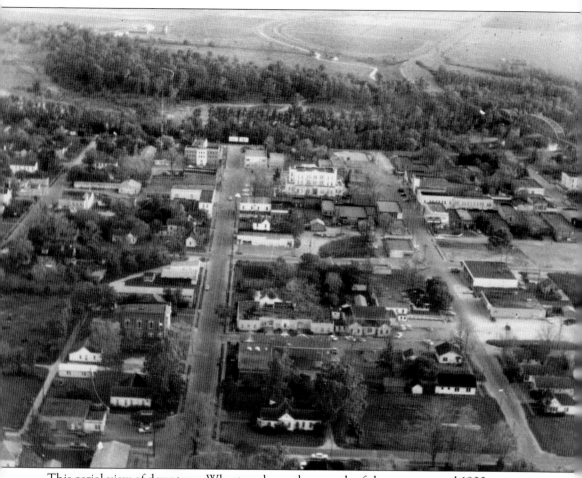

This aerial view of downtown Wharton shows the growth of the town around 1900.

Five

A TEXAS SMALL TOWN
CULTURE EMERGES

In the years immediately preceding and following the Civil War, tiny Wharton claimed little except its own postal station, a general store, a bank, county seat buildings, and a jailhouse, and a smattering of residences along dusty cart roads. Wharton served as a stagecoach stop for the Victoria-Houston route and an important mail route station between Matagorda and Columbus, but its population grew very slowly.

Following the arrival of the railroads in the 1880s, however, a broader culture grew out of the Colorado prairie grasses, ripe with an evolving society built on agriculture and ranching, religion, education, and an influx of European immigrants. Associations and organizations operated their business interests in the lobbies of fine hotels, while an opera house and theater added an artful flair to the growing community.

In 1912, the city leaders raised money to begin a county fair, and its long and illustrious history so began with support from Wharton, El Campo, East Bernard, Iago, and Louise. A grand parade began the festivities each year, accompanied by horse races, a carnival, merchants' displays, and a plethora of food for every palate. The 4H and Future Farmers of America (FFA) clubs have grown out of the fair's objectives, and a youth rodeo was organized in 1949.

Education has always been a priority for Wharton, and its schools have proudly generated thousands of bright young graduates, sending them out into the world to make their mark. A junior college established in 1946 continues to graduate students from several counties 65 years later.

The Wharton town square looked like this in the early days. One of the most controversial issues in the early decades of Wharton's history focused on the muddy streets that seemed to continually plague the merchants and citizens. Paving the streets proved a long time coming.

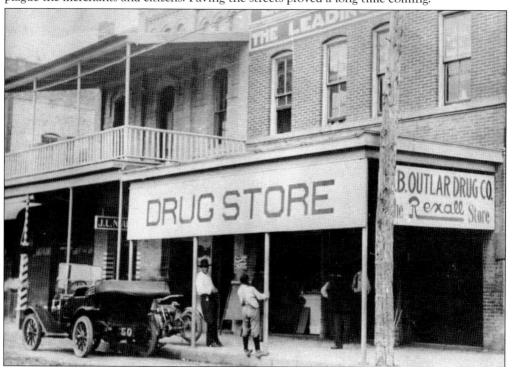

Dr. Leonard Bela Outlar was a prominent Wharton citizen who developed a "Chill and Fever Tonic" around 1900 and opened his drugstore on the square. Other early physicians included Mason Weems from Virginia, Bat Smith, B. R. Valls, A. L. Lincecum, and Green Davidson. Dr. Davidson owned the first automobile in Wharton.

CORNER OF HOUSTON & MILAM STREETS

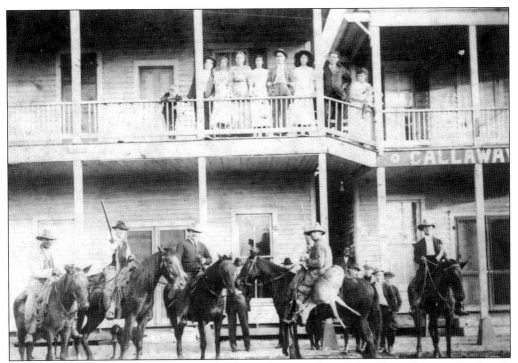

The Callaway Hotel was one of the oldest hotels from the late 1800s. One of the earliest hotels built on the Wharton square, the Callaway boasted a second floor and wide balcony for its guests to view the courthouse and grounds.

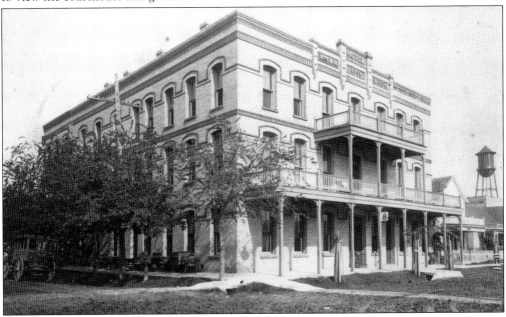

The Nation Hotel was managed by the flamboyant Lillian May Nation. This three-story, 26-room edifice on the corner of Polk and Burleson Streets was a preferred boardinghouse for many of the wealthier visitors to Wharton. Under the ownership of the Vineyard family, it later became the Blackstone Hotel.

1901

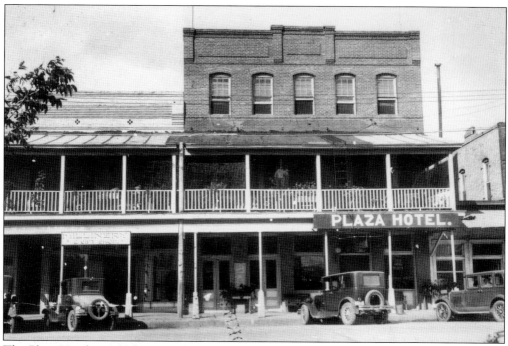

The Plaza Hotel struck this view from outside on the street and in the lobby. The Plaza stood on the square on Houston Street and was managed for many years by the gracious R. B. Huston. The hotel included a spacious dining room and lobby where banquets and conference meetings could be held, and Sunday dinners were a long-standing community event. The hotel was sold in 1941 and refurbished as the Plaza Theatre.

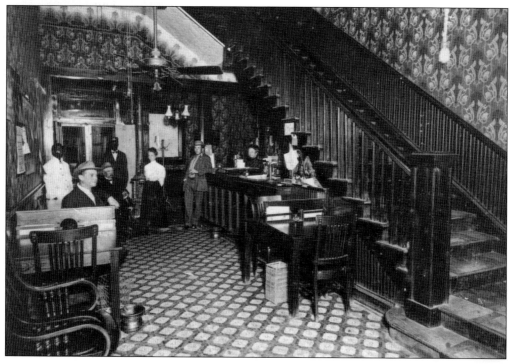

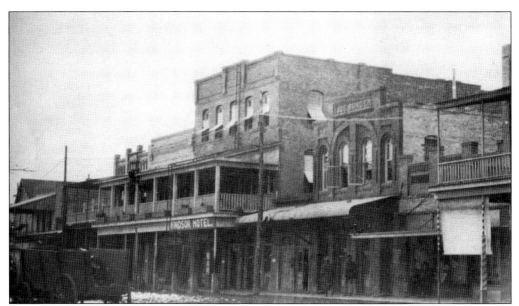

The Windsor Hotel boasted some of the wealthy visitors to Wharton. Besides the Windsor, other hotels and boardinghouses that came and went in and around Wharton's square included the Ford Hotel, operated by Sophie Ford; the Davis Hotel, which also contained the Cunningham Grocery downstairs; and the Riverside Hotel on Burleson Street.

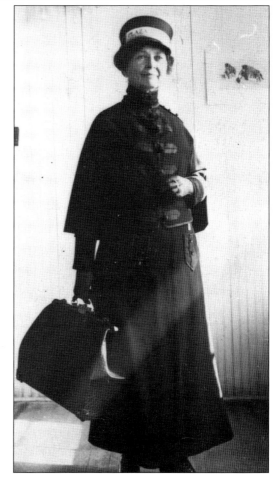

Lula Huston made friends as one of the earliest hotel managers in Wharton. Well-respected across the community for her social graces, Lula often dressed as a bellhop to greet guests and unload baggage.

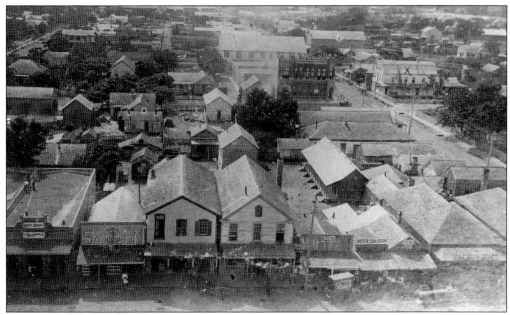

"Saloon Row" stands in Wharton just off the square. It was strictly off-limits for the women and children of Wharton but was frequented by the men and the rowdy element as well. At one time in the early 1900s, there may have been as many saloons in town as churches. A fire some years after this photograph was taken razed the entire street and destroyed all the saloons there. Some suspected arson by fiery temperance supporters.

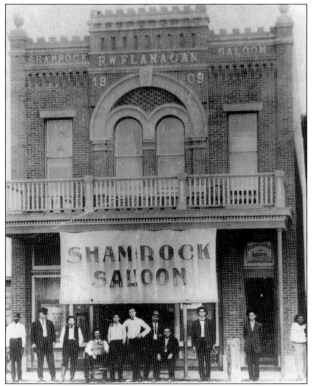

The Shamrock Saloon, pictured in 1926, did business for two decades or more. Most of the saloons in the early 1900s were located along the west side of the square, and ladies were discouraged from walking in that vicinity.

LOCATE ON SUNSET ST. BY (2018) MOSES GIN
& ACROSS STREET OF RAIL ROAD DEPOT

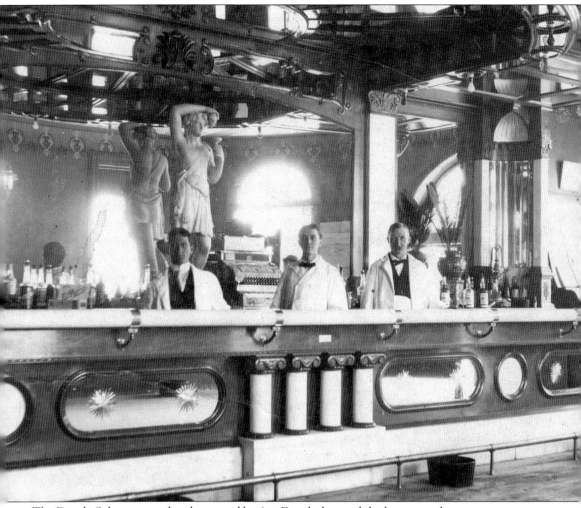

The Dawdy Saloon, owned and operated by Asa Dawdy, boasted the longest and most extravagant bar in the county, replete with statues, detailed woodwork, and an enormous mirror. Dawdy's establishment was said to have more expensive paintings and statues than any of the finest homes in Wharton County.

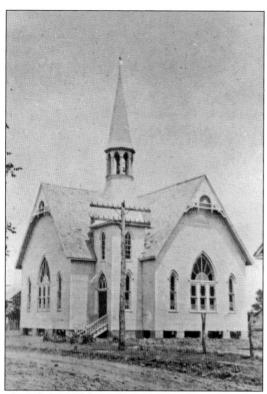

First Methodist Church's faithful in Wharton hosted Methodist preachers who rode the Bay Prairie circuit early in the republic years, and a Methodist congregation formed in Wharton soon thereafter. The first building stood on Caney Street. The next building, on Fulton Street, suffered from the 1909 storm and was destroyed in a 1925 fire. A redbrick building went up in 1927.

Even before there was a formal First Baptist Church in Wharton, William Kincheloe hosted a Baptist Sunday school in his home prior to 1835. The Burleson Street church was destroyed in the 1899 hurricane and rebuilt on South Rusk Street 10 years later. Amanda Watts and L. B. Outlar avidly supported the children's Sunday school for many years.

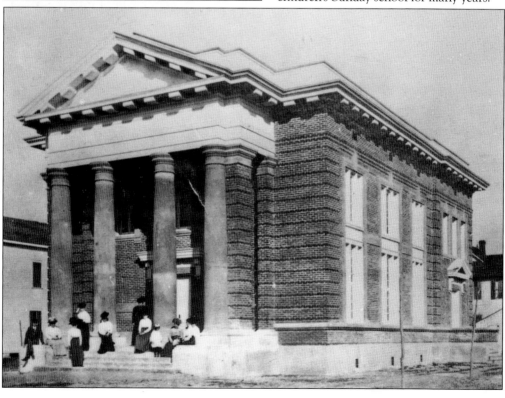

Holy Family Catholic Church came decades after Fr. Michael Muldoon itinerated through Austin's colony in the 1830s. Holy Family was organized in 1912 by Basilian priest Fr. George Montreuil and met in city hall or the Queen Theatre at times; a new structure was built in 1929. Holy Family School was organized in 1947.

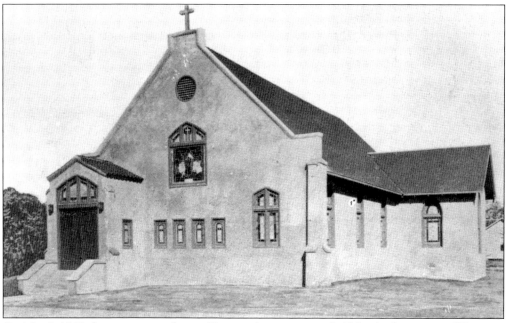

On May 5, 1866, despite torrential rains, Episcopal services were held for the first time in Wharton. St. Thomas's Mission Church held services beginning in 1898, and new buildings were constructed in 1902 and 1951. The congregation of St. Thomas was admitted as a parish in 1920.

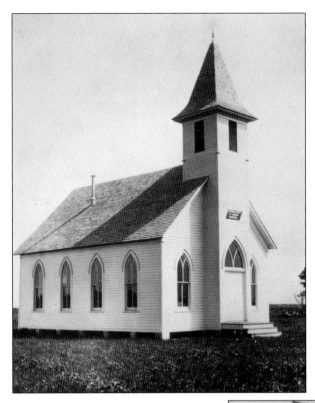

St. John's Lutheran Church looked like this before the fire that razed it. German Lutherans organized two congregations in 1901, one in Wharton and the other in Glen Flora. The first pastor rode a seven-town circuit. One building was destroyed by the 1900 hurricane. In 1930, St. John's was built on Pecan Street, and soon after, St. Paul's Lutheran moved its congregation to Wharton.

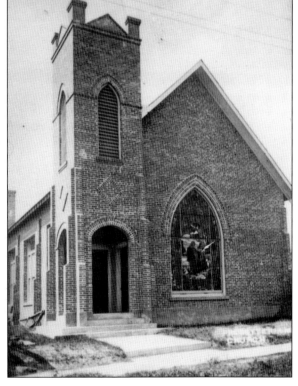

The Presbyterians organized in the early 1900s and built a church on South Fulton Street in 1906; that building crumbled in the 1909 storm. The church was rebuilt debt-free in 1912. One of its earliest pastors was Dr. W. S. Red, a well-known theologian and church historian.

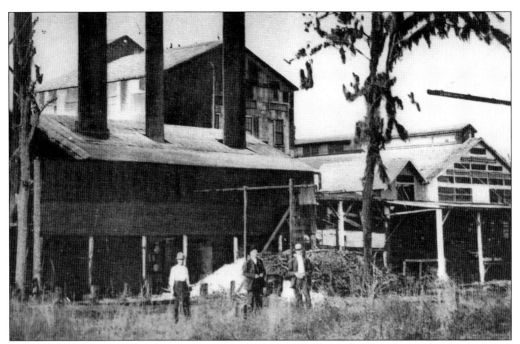

The W. B. Kemper sugar mill in Wharton suffered from economic and operations failures from 1907 until it finally closed down in 1914. The Waterhouse Rice and Sugar Company in Glen Flora ran a much more successful operation until the 1909 storm and a cane blight in 1913 essentially ended the industry in the county. In the 1870s, there were so many sugar mills in the area that it was known as "the sugar bowl of Texas."

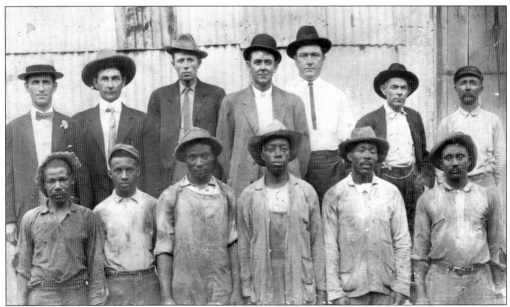

People's Oil and Cotton Mill in Wharton was built by G. C. P. Gifford in 1900 as the Cottonseed Oil Mill. The mill covered a large site that included an eight-stand cotton gin. The company was sold in 1920 to partners from Houston and Galveston and continued to operate in Wharton.

IS THIS WILL WOODS? NOTE LEFT EYE.

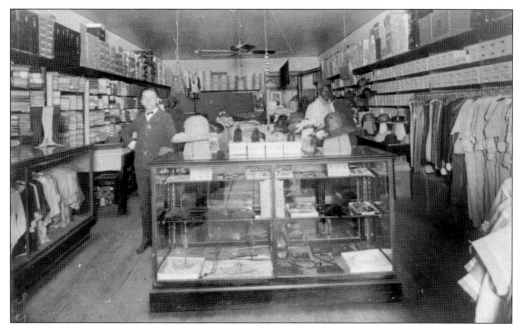

Clerks at Wharton Dry Goods Store, at 110 South Houston Street, welcome patrons in the 1920s. Except for the stores in El Campo and Mackay, Wharton served as the only mercantile center on the Bay Prairie, with Victoria and Houston too distant for casual trips to town.

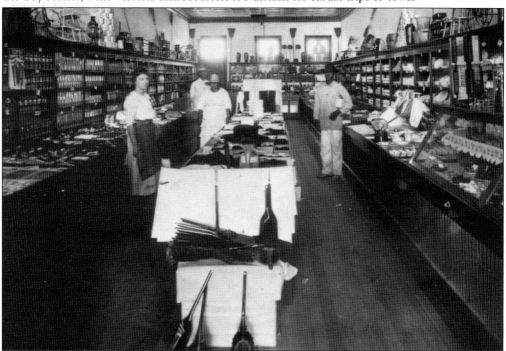

Moffitt's Dry Goods Store, on Houston Street, had a diverse clientele in 1921. Other establishments on the Wharton square in the 1920s included the Security Bank and Trust, the Blackstone Hotel, Outlar's Drugstore, Wharton County Abstract Company, a grocery, a barbershop, and a furniture store.

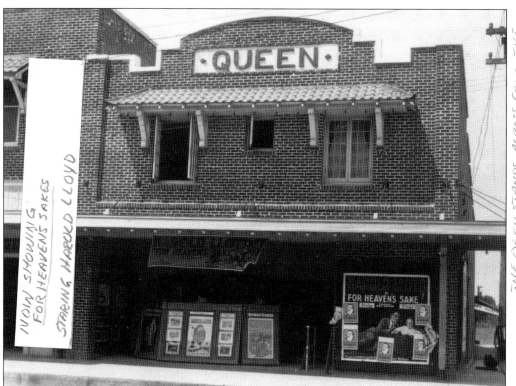

NOW SHOWING FOR HEAVENS SAKES

STARING HAROLD LLOYD

FOR HEAVEN'S SAKE

THE QUEEN STANDS ACROSS FROM THE WHARTON BANK & TRUST BLDG. AND ON THE SE CORNER OF MILAM & POLK STREETS- NORTH EAST

The Queen Theatre stood proudly on the square in the 1920s. Joe Santos built the Queen at the corner of Polk and Milam Streets and operated it for many years. Wharton's first "talking picture" was shown there in 1929. The Rio Theatre, on Richmond and Milam Streets, stood across from the three-story Norton Opera House.

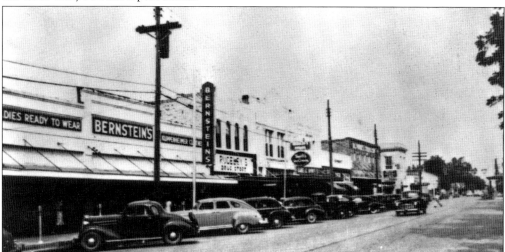

Milam Street businesses in 1936 stay busy as automobiles line the storefronts. Wharton's mercantile businesses struggled during the Depression years but managed to recover by the mid-1930s and thrived during the productive war years. The Manhattan Café stood on Houston Street, and the Plaza Hotel added a third floor. J. T. Murphy owned a hardware store to compete with Rooker and Dotson's on Fulton Street.

Educator Amanda Watts poses with four children surrounding her. The first schoolteacher in Wharton, the widowed Watts came to the town in 1880 and operated a boardinghouse on the square where the Riverside Hotel was later built. Her school had 22 pupils enrolled.

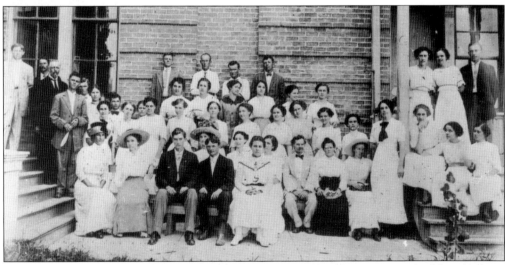

The Wharton County Teachers Institute, its faculty pictured here in 1912, served public education in Wharton. The first official Wharton public school system was incorporated in 1896 with William Foster employed as its first principal and W. Hathan, R. H. Harris, and S. M. Martin as principals of the three African American schools. In 1913, Merle Wharton became superintendent of the schools; all of her teachers were female.

The Wharton High School graduating class of 1908 strikes an informal pose prior to commencement exercises. Professor Lyle stands in the back row. In the front row on the right is Hallie Brooks, Horton Foote's mother.

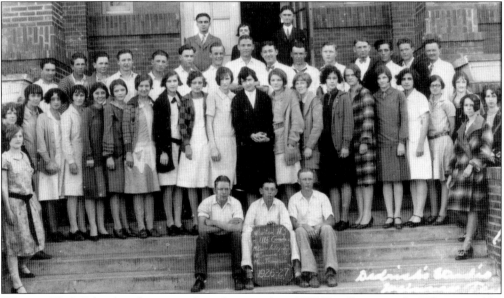

Wharton High School students pose for a photograph in 1927. Enrollment in the Wharton public schools in 1927–1928 totaled 1,682 white students and over 1,000 African American students in the segregated "common" district.

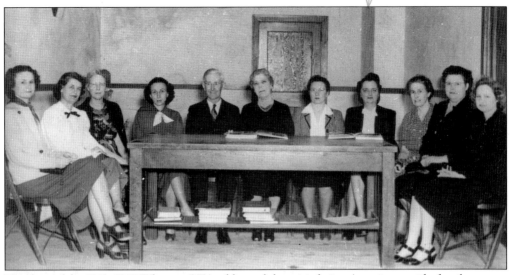

Members of the 1941–1942 Wharton PTA addressed the crisis facing America outside the classroom. The largest concern for the schools was America's entry into World War II in December 1941. High school boys aged 16 and older could only wait for their opportunity to enlist and serve, and classrooms kept busy with projects to support the growing war effort.

John M. Hodges became superintendent of the Wharton schools in 1915, and for eight years, his remarkable efforts brought the town's school system into the modern age. He returned to Wharton after a 22-year absence to help organize and lead the new junior college.

Several members of the Speaker family of Wharton became teachers, and two generations served in the world wars. C. L. and Garland Speaker lived nearby in Egypt, and Eddie Speaker Jr. was a talented football player for the Wharton Training School Wolves.

C. W. Dawson was the first principal of Wharton Training School. During the decades of segregation, African American schools in Wharton included Dave Wood School, Alta Vista, and Jack Ford School. The high school, first named Dunbar High, relocated from East Avenue to Canton Street. H. F. Edwards served as the first principal of the African American schools.

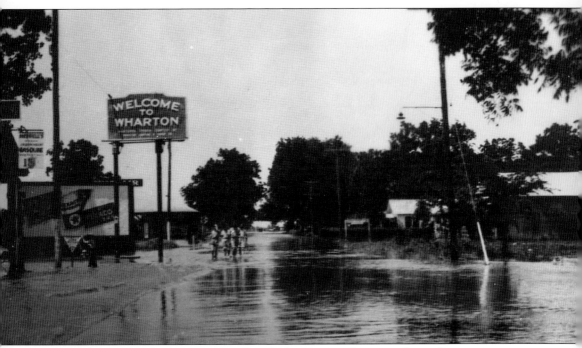

A "Welcome to Wharton" sign stands in high water, sending mixed signals to visitors.

CORNER OF RICHMOND RD. (HWY 60) + OGDEN ST. (102)

Six

THE RIVER RUNS
THROUGH IT

The Colorado River has been largely untamed for all of its thousands of years since the Ice Age and the Gulf Coast receded. The "Twin Sisters," the Brazos and Colorado Rivers begin far up near the caprock of the Texas Panhandle, wandering a parallel course south and east before spilling into the Gulf of Mexico only 43 miles apart from one another. The Brazos River meanders over 840 miles from its confluence in Stonewall County to its mouth at Freeport, while the 600-mile-long Colorado crosses 19 county lines from Dawson County, through Wharton, and to Matagorda.

The rains often begin up-country in Austin or Fayette County, swelling the myriad creeks and streams for the 100-mile trip to the coastal plains, and splashing the water over the banks and across the flat prairie. Sometimes they come in powerful hurricanes or tropical storms, pounding across the Gulf of Mexico and slamming through Brazoria, Matagorda, and Freeport.

The drenching rains inundate farm and home and city alike, showing no preference and no mercy, and Wharton is no exception to the flooding devastation. Particularly ravaging storms struck the town in the late 1880s, 1900, 1909, 1913, and 1935, causing millions of dollars in damage and drowning settlers and livestock in their wanton path. In the 1913 storm, many say the worst of them all, the Colorado and Brazos Rivers formed one horrific current 20 miles wide as they flooded together upstream from Wharton County. Rain and wind in 1935 killed more than 800 birds in the city limits alone, and a 1945 hurricane dropped 30 inches of rain on the town in only hours. Hurricane Carla in 1961 is still remembered today by its survivors.

Freakish snowstorms strike Southeast Texas, like the one on Valentine's Day in 1895, while equally extreme summer temperatures nearing 110 degrees have done their own damage. The rise and fall of the Colorado River measures the courage of its people.

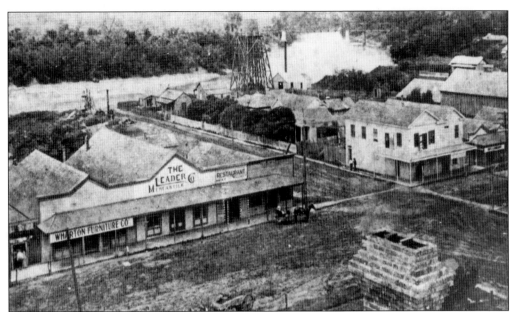

A bird's-eye view of Wharton includes the Colorado River meandering nearby.

FROM ATOP THE COURT HOUSE LOOKING WEST

BURLESON ST

HOUSTON ST

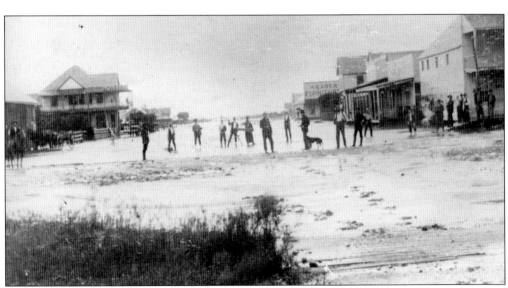

People wander across a flooded town square. Storms in the mid- and late 1800s, though not recorded as they would be in modern annals, struck with the same fury and did the same amount of damage on the growing young town of Wharton. Newspaper stories trace the horrors of storms in 1843, 1853, and 1869.

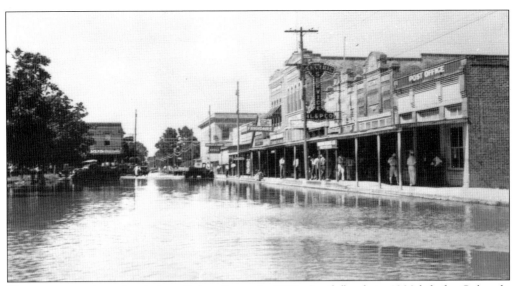

The square was inundated along Fulton Street in 1900. April floods in 1900 left the Colorado River high above its normal level and over its banks, and Caney Creek swelled to more than 200 feet wide. Young Lucy Rogers lost her home and her sister, escaping the collapsing building when the high winds tore through the town; her mother managed to survive in the fallen house, where she chose to remain with her deceased daughter.

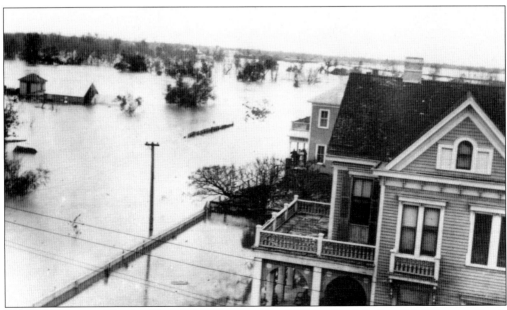

Even as far away as Topeka, Kansas, headlines in April 1900 told of the horrible Wharton flood, pictured here, that killed a young African American boy named Will Mathis. Will became stranded on a spit of land that had become an island but tried to swim to safety as the water rose and was lost to the raging current.

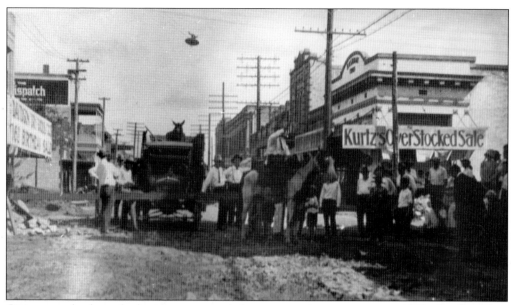

Citizens wade through the incessant mud that once was a city street in 1900. On Saturday, September 8, 1900, a hurricane and storm surge ravaged Galveston Island and killed 6,000 people before heading inland, the worst natural disaster in U.S. history.

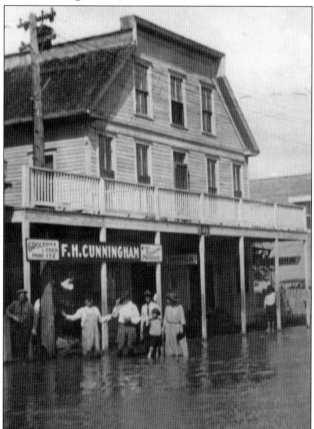

The Davis Hotel and Cunningham Grocery find themselves under water in September 1900. Flooding in Wharton began on September 9 and continued for 15 days as the hurricane-bolstered Colorado River rampaged back into the Gulf.

MILAM ST.

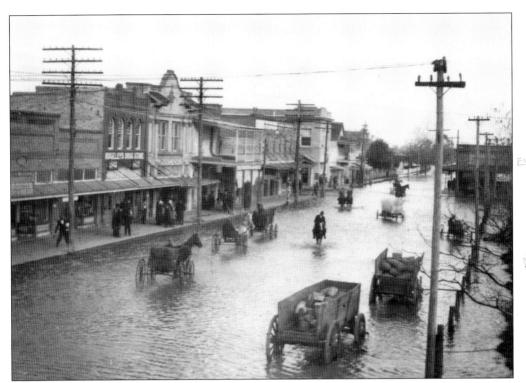

FULTON ST

MILAM ST.

A hurricane struck the coast near Velasco on July 21, 1909, destroyed that coastal town, and left 41 dead in its wake. A 20-foot storm surge in Freeport was matched by the flooding Colorado River, which swept through downtown Wharton during the remainder of July.

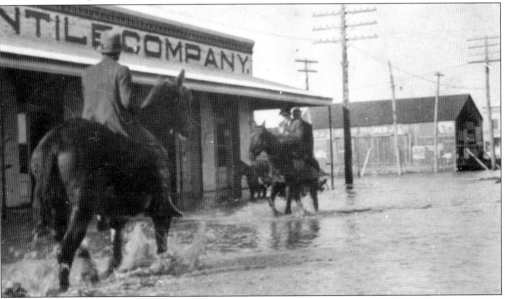

Wharton citizens take to old-fashioned transportation downtown. An unprecedented 16 inches of rain deluged San Marcos, Texas, on December 1, 1913, and flooded both the Colorado and Brazos Rivers. The two rivers and the San Bernard joined as one horrific megariver near Wallis above the Bay Prairie.

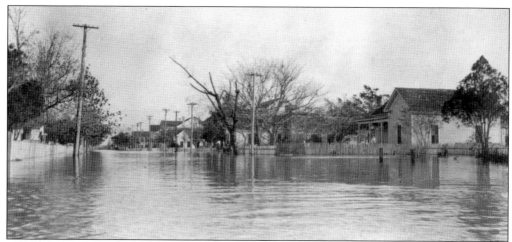

For seven grueling days in December 1913, the cold winter floodwaters poured down toward the coast. Burleson Street looked like this. The town of Columbus, just north of Wharton County, became a stranded island for days, and people in several towns, including Wharton, were forced to climb trees for safety.

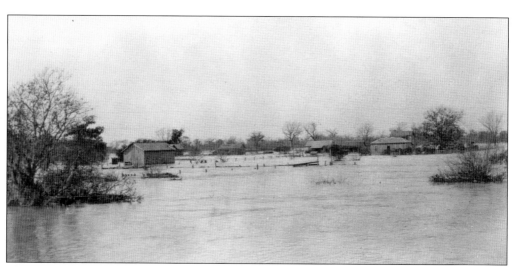

The outskirts of town at the height of the flooding, on December 8, 1913, left damaged buildings and roads. The Colorado River was running at 51 feet, 9 inches—31 feet above flood level and right through the middle of Wharton.

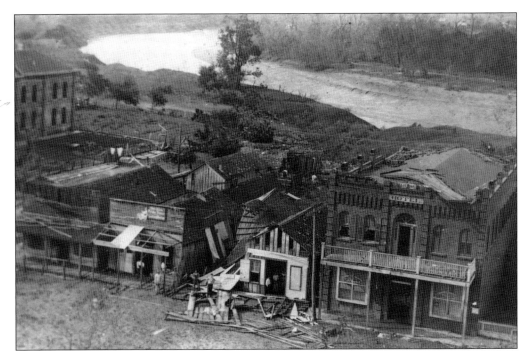

Damage from the 1913 winter storm proved deadly. One hundred eighty people perished in the floods along the Lower Colorado Valley, including nearly two dozen in Wharton alone. No storm has done such damage since. *BURLESON ST* *FORD HOTEL*

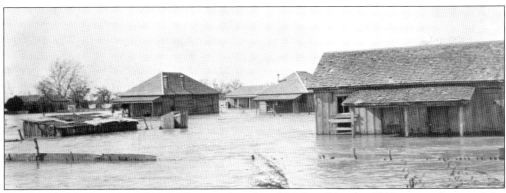

The Lloyd Rust farm outside of Wharton found itself deluged by the 1913 waters. Livestock by the tens of thousands washed away from the Bay Prairie and eventually to the Gulf. No estimate was ever made of the millions of dollars lost by the destruction.

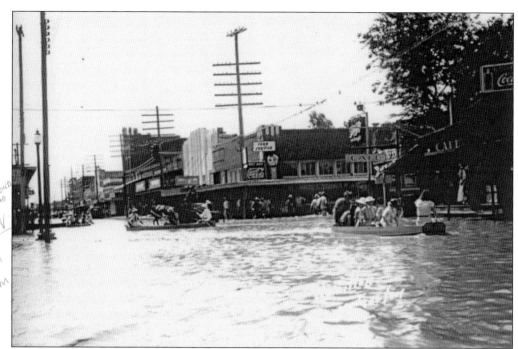

Floodwaters pour into Wharton in 1935. Over 20 inches of rain was recorded in the spring rains of 1935 as creeks and tributaries from the city of Austin to Brazoria County spilled into the Colorado, San Bernard, and Brazos Rivers.

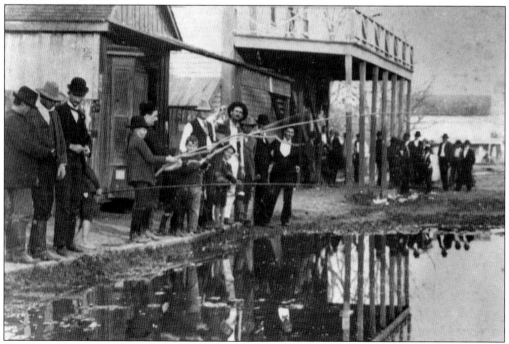

For three months in the spring of 1935, it rained on the Colorado River prairies. The river measured over 20 feet above flood stage in May and 51 feet deep on June 20. Constant problems with the city streets for half a century provoked this mock picture of fishing in the downtown "river."

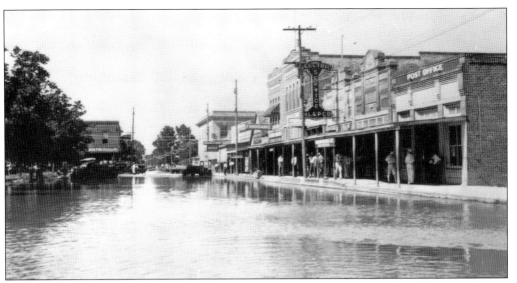

FULTON ST.

The floods of 1938, pictured here along Fulton Street, covered the countryside of Wharton County and inundated the city itself, cutting roads and railways and destroying bridges.

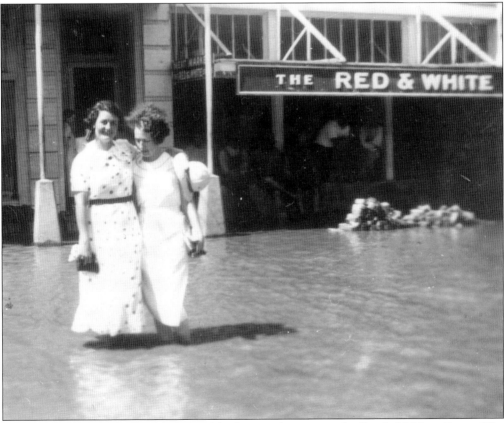

Nan Outlar (left) and a friend pose ankle deep in the waters of a flooded Milam Street. The people of Wharton adjusted to the vagaries of the flooding river, making light of situations when all else failed.

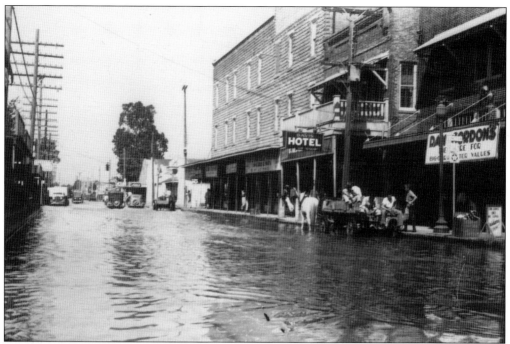

West Milam Street businesses could not stop the damage during the 1935 flood. Ten years later, in late August 1945, a brutal hurricane dropped 30 inches of rain inland as far north as Wharton and El Campo, ruining $20 million of cotton crops and pecan trees. The hurricane spawned deadly tornadoes along the Bay Prairie, and several buildings in Wharton were severely damaged. Miraculously no one died.

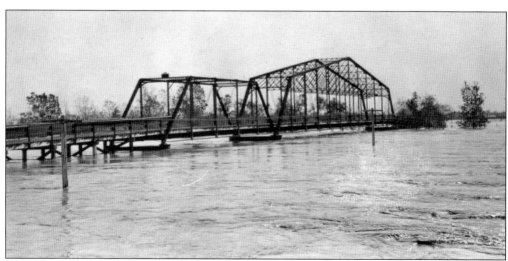

The bridge spanning the Colorado River a mile north of the city closed down during the most severe of storms, in 1935, 1945, and 1961. At one point in 1935, hundreds of people became trapped for almost two days in the one school that sat on a hill at the edge of town.

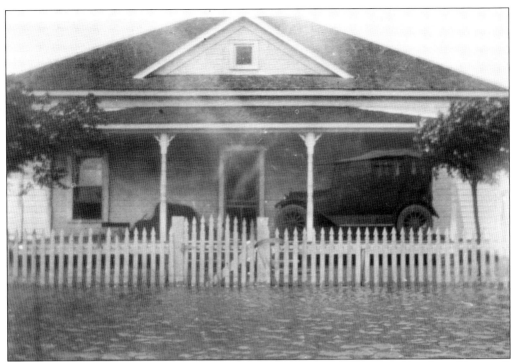

A quick-thinking citizen safely stores his automobile high on a front porch. People and livestock sought safety wherever they could find it, and Wharton folks salvaged what they could before and after the storms.

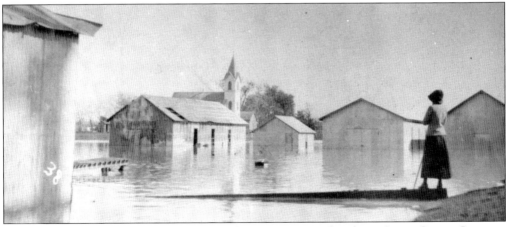

A woman stares forlornly out over the flooded town from a church on Caney Street. Category Four Hurricane Carla slammed into Texas near Port O'Connor on September 11, 1961, with 115 mile-per-hour winds and a 22-foot storm surge, the strongest storm ever recorded in Texas to that time. Wharton native and newsman Dan Rather reported the storm live from Galveston.

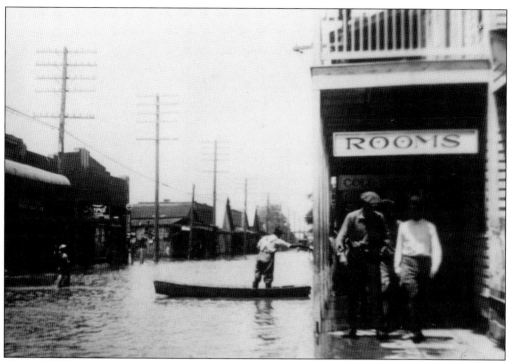

The Davis Hotel stands precariously above the flood waters. Wharton suffered from other disasters during its history in addition to hurricanes and floods. A downtown fire on December 30, 1902, destroyed 24 offices at an estimated $60,000 damage. George Brown, an African American Wharton resident, died while helping to put out the fire. An entire city block of buildings was lost.

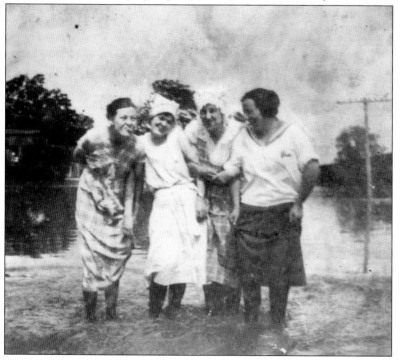

Four women make the best of things during the storm. Drought and floods and heat waves and freezes alternatively did their damage across the Bay Prairie; no generation escaped the weather's power.

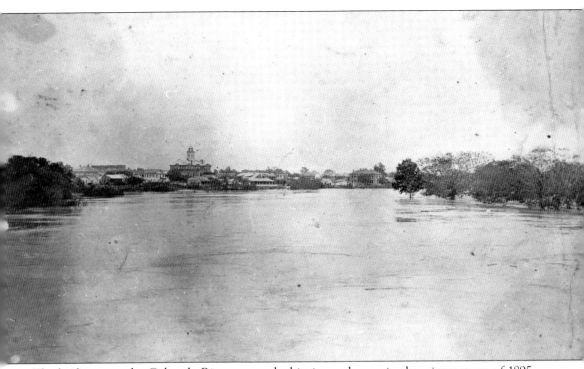

The bridges over the Colorado River were caked in ice and snow in the winter storm of 1895. The Valentine's Day snowstorm set a record in Wharton unmatched until the Christmas Eve blizzard of 2004. At the other extreme, the torrid heat of typical summer months in Southeast Texas have taken their toll over the decades, never hotter than the deadly July days in 1939 when the temperature hovered at 110 degrees.

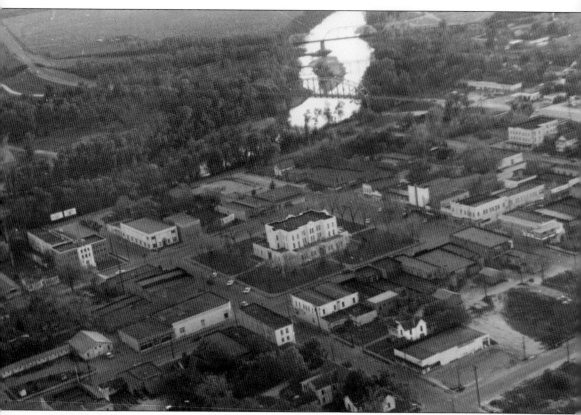

By 1960, the thriving town of Wharton looked like this from an aerial view.

CANEY ST →

FULTON ST

Seven

FACES OF WHARTON'S HERITAGE

For such a relatively small town, Wharton's several generations have claimed and proclaimed an impressive list of influential people who have represented the community in places both near and far. The earliest names include Horton and Borden, Heard and Northington, and the colorful "Buckshot" Lane and "Shanghai" Pierce.

Notorious cowboys like Forrest Damon and Charlie Siringo rode from and through here, and a Japanese baron and international businessman came to invest in the rice farms nearby. National Football League players Leroy Mitchell and James Kearney grew up in Wharton and played for the Wharton Training School team; Mitchell's team won a state title in 1962. Railroad magnates named Mackay, Telferner, and Hungerford founded towns in the area, while Texas-size ranches like that of the Hudgins family made their mark on global cattle interests. J. M. Hodges helped lead the junior college to national prominence, while Wharton native James E. Chase launched a remarkable career of service and became Spokane, Washington's, first African American mayor.

Most famous of the recent Wharton citizens are national news anchor Dan Rather and the noted late playwright Horton Foote, both proud to claim their heritage back home on the Lower Colorado.

A. C. Horton (1798–1865), an early Wharton settler, served as the first lieutenant governor of the Republic of Texas in 1846 and several months as interim governor between May and November of that year. He owned land on Caney Creek near Wharton, ran a sugar mill on his Sycamore Plantation, and lived out his last years in Matagorda.

Frederick Law Olmsted (1822–1903) made his way into Texas in 1854 to explore the South, its landscape, and its institution of slavery. The father of American landscape architecture, Olmsted and his brother traveled a broad swath across Texas for most of a year. On April 29, 1854, on the Colorado River, he wrote: "We were landed from the ferry near night and camped under a group of huge oaks at the edge of the great coast-prairie. . . . The soil throughout the district was admirably adapted for cotton, a rolling surface beautifully broken by clusters and irregular groves of trees."

John Holland Forgason served as a Civil War officer in the Confederacy. Only two votes were cast against secession from Wharton County in 1860 as Texas entered the war. Whartonites joined Terry's Rangers and the Home Guards to fight. The sugar industry, key to the Confederacy and destroyed by the Union occupation, and the South's antebellum plantation life never recovered after the war ended.

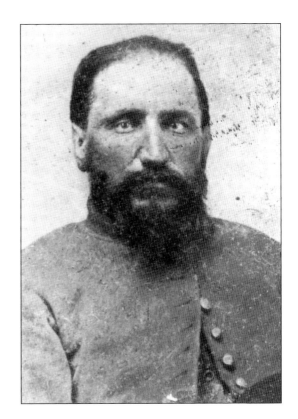

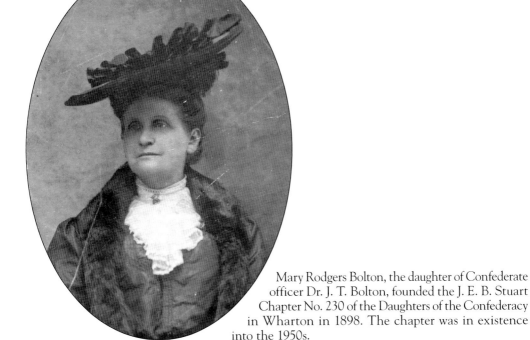

Mary Rodgers Bolton, the daughter of Confederate officer Dr. J. T. Bolton, founded the J. E. B. Stuart Chapter No. 230 of the Daughters of the Confederacy in Wharton in 1898. The chapter was in existence into the 1950s.

Two generations of the Outlar family ran the only drugstore in Wharton and practiced medicine across the Bay Prairie area. Bolton Outlar, pictured here, and his wife, Nan, were always active in Wharton's civic affairs.

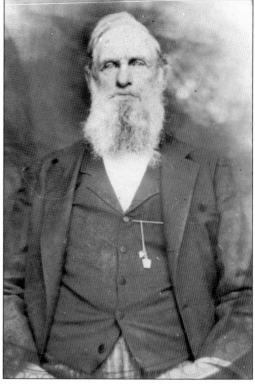

Dr. Ed A. Martin, a Wharton physician, was one of several who practiced in Wharton, including Drs. N. H. Wireback, Phil and Jack Phillips, J. W. Veazey, B. R. Valls, Simon Neal, and J. M. Andrews. A hospital was built in Wharton in the mid-1900s to serve the county.

Judge W. J. Croom poses with his grandchildren at his side. Wiley and Marienne Croom served the Wharton community for several decades, and a street and a city park were later named for them. Judge Croom worked as late as 1930 to help establish the Wharton County Fair.

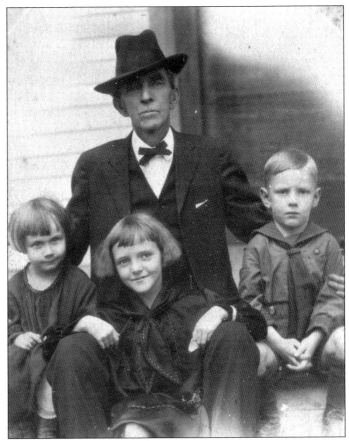

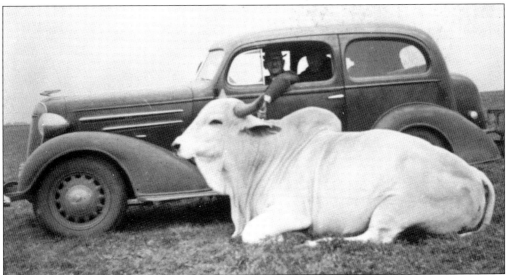

Walter Hudgins shows off his new automobile and a Brahman bull. The Hudgins estate near Hungerford helped define the cattle and ranching industry on the Bay Prairie. Known internationally in the cattle industry, the Hudgins name stands into the present as a leader in Southeast Texas ranching.

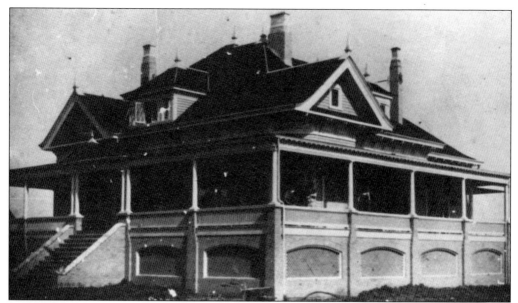

One of the fine mansions in Wharton was the Sorrell Home on Milam and Resident Streets in 1909. Richard Henry Douglass Sorrell Jr., a wealthy landowner, state legislator, and civic leader, built this home with a cypress exterior and mahogany interior. In 1899, he gave land to the city to build Wharton High School.

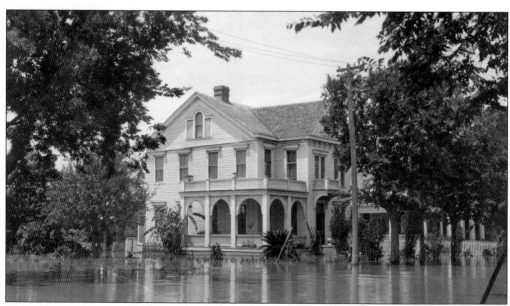

The majestic Vineyard Home on the corner of Burleson Street and Richmond Road always attracted visitors. Robert E. "Bob" Vineyard served as Wharton's mayor, was on the first public school board, and helped persuade the railroads to add a line to Iago in Wharton County in 1900. The beautiful Vineyard mansion burned in 1924.

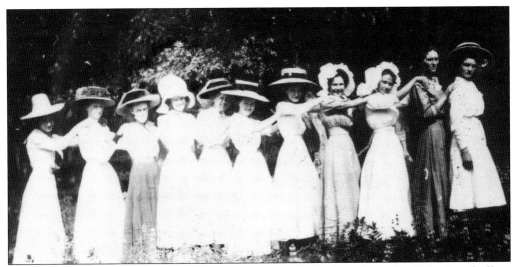

Eleven of Wharton's high society ladies stroll through the park in the early 1900s. Social affairs in Wharton added grace and style to the community. Pearl and Marjorie Compton are second and third from the left, and Hallie Brooks is fifth from the right.

The Hamilton girls relax on their front porch in 1900. From left to right are Sophie, Mary Ann, Christine, and friend Rita Schultze. J. A. Hamilton of Wharton served as president of the school board from 1899 to 1900. Children in Wharton enjoyed the adventurous country life while at the same time growing up in a town known for its culture and education.

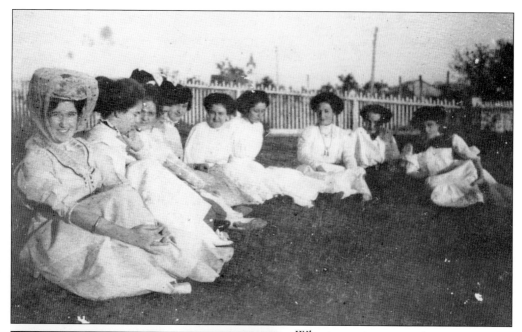

Wharton matrons pose in a 1910 photograph. Women of the community stayed active in church and civic affairs and often participated in various organizations that supported the community.

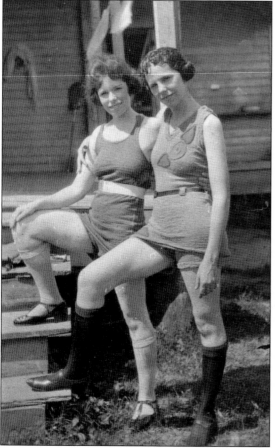

Bathing beauties strike a pose in the Roaring Twenties. Aline Houseworth (right), daughter of W. L. Houseworth, Wharton's county treasurer from 1932 to 1956, and her friend would have been considered daring to be seen in public dressed in the "modern" garb of the day.

IS THAT FRIEND EVA BELLE HALE FRAZIER ?

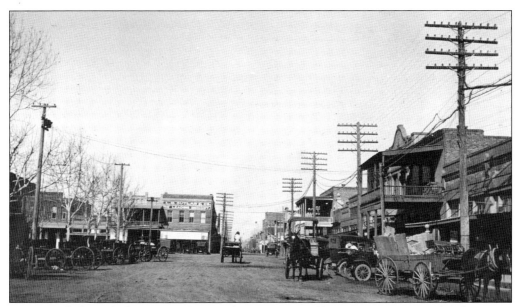

Wagons roll through the streets of 1919 Wharton. As World War I came to an end and veterans made their way home, Wharton began to grow again, and the railroads, cotton, and ranching led the way. In 1919, Clarence Kemp was sheriff, Joel Hudgins was tax assessor, and W. G. Davis was the county judge in his third of five terms. MiLam st.

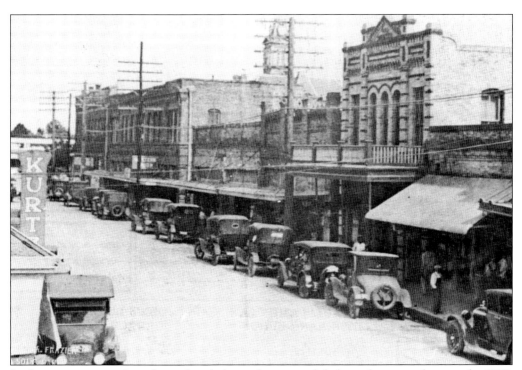

In the same view as above but a decade later, the automobile has taken over the town by 1928. The Gifford Motor Company came a few years later, and Belcher's Tee Pee Courts attracted visitors as they crossed the country. East
MiLam st.

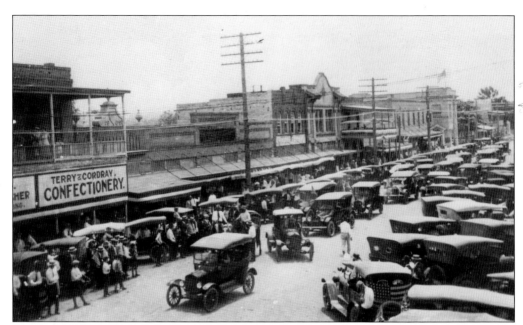

On the Fourth of July in 1911, downtown Wharton was flooded, but not by the river. Thousands poured into the square to celebrate Independence Day.

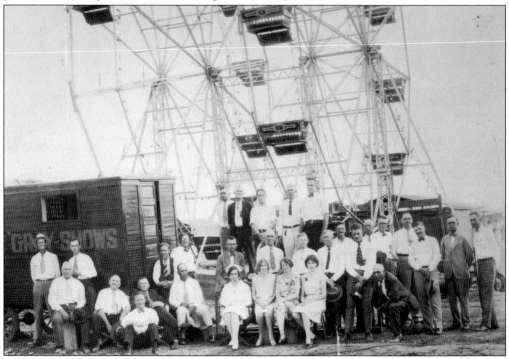

The county fair's giant Ferris wheel is a perennial favorite attraction. With land donated by the family of early settler Fritz Ahldag, whose name adorns a street in the city, Wharton organized its first county fair in July 1912. But it was not until 1930 before the fair expanded and built a permanent site with 20 acres and several buildings on the Boling Road and became a major attraction for the city.

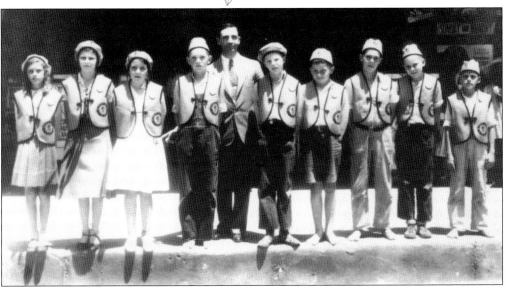

Members of Wharton's chapter of the Mickey Mouse Club in 1932 display their ears. Despite the agonies of the Great Depression, which struck across the country and especially hard in the Midwest and into Texas, children of all ages managed to find things to enjoy, including the clubs started by the Disney Company in 1929.

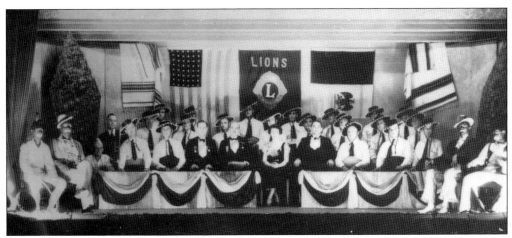

The Lions Club of Wharton puts on a traditional minstrel show for the Wharton audience. Clubs and organizations dotted the city's landscape through the 1900s, including the Rotarians—established in Wharton in 1946 and sponsored by the El Campo Club, Elks, Masons, Woodmen of the World, and the American Legion.

In 1900, members of the Knights of Columbus chapter in Wharton and the Catholic Union pose for an annual photograph. The Catholic Union chapter has always been particularly active among the Czech settlers and their descendants across Central Texas and in Wharton County.

Adolph and Christina Shoppa pose in 1918 for their wedding portrait. The national Orphan Train Movement out of New York City had Texas on its destination maps from 1854 to 1929, and nearly 2,000 orphaned children found foster homes here. Christina Keller arrived in Ellinger in 1905 and then came to Wharton, where she met and married Adolph Shoppa. (Courtesy Kay Shoppa and Lloyd and Betty Shoppa.)

The Wharton baseball team poses in its 1912 season. Sports have been a defining character of the Wharton community for over 100 years. Baseball and the rudiments of football came to town in the late 19th century and blossomed with rivalries against Bay City and El Campo over the years. Softball, volleyball, and basketball followed soon after.

The Wharton High School football team, posed here in 1920, attracted the townsfolk to its Friday night games. Fridays in the fall means high school football in Texas, and the Bay Prairie stadiums are no exception. The Wharton Tigers kept high standards of winning seasons, with titles in 1930, 1939, and again in the 1940s.

The 1950 1A state football champion was the Wharton High School Tigers. The 1950 team under coach Hank Mangum went 14-0-1, only gave up 68 points to its opponents for the whole season, and defeated Kermit 13-9 for the state title. Key players on the squad were Johnnie Franke, Julius Smolik, Brink Brinkley, and Mitchell Torok.

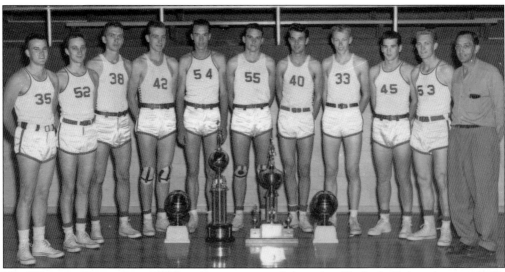

The Wharton County Junior College Pioneers earned the title of basketball champions in 1952. The team swept through the regionals and won the national junior college title. Two years earlier, the junior college's football team went undefeated through its regular season, was ranked first in the nation for two months, and lost its only game in the Tyler Rose Bowl in December.

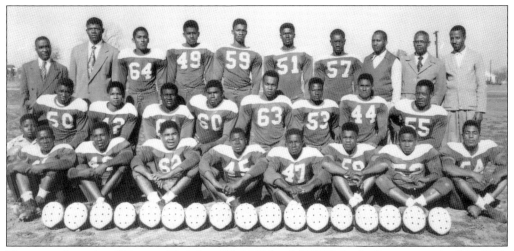

The state champion Wharton Training (High) School (WTS) football team won it all in 1962. In the segregated Texas leagues, the WTS Wolves went 12-1 in 2A play and defeated Lubbock 40-6 for the state title. Key players were Robert Edwards, Eddie Speaker, Willie Rhoades, Leroy Mitchell, and Allen Branch. Mitchell later played cornerback for seven seasons in the National Football League (NFL) and was in the 1968 Pro Bowl.

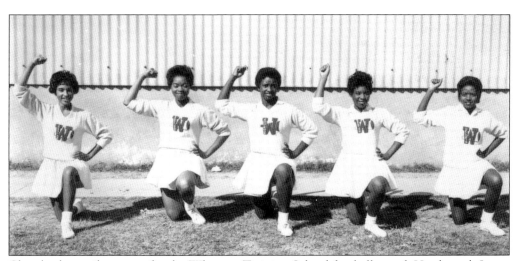

Cheerleaders strike a pose for the Wharton Training School football squad. Head coach James Wanza played football at Texas Southern University before coming to Wharton, where he led the Wolves to several district titles in the 1960s. Wolves defensive standout James Kearney played 11 seasons in the NFL from 1965 to 1976, most of those as strong safety for the Kansas City Chiefs.

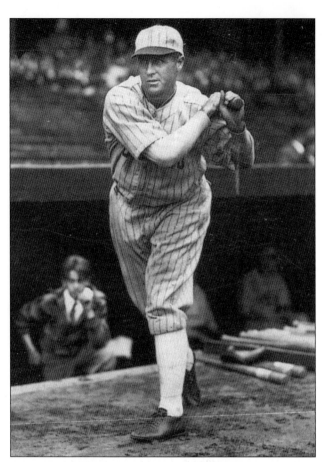

Carl Netter Reynolds (1903–1978), a Wharton native and professional baseball player, played more than 13 seasons in the major leagues as an outfielder for the White Sox, the Cubs, and the Red Sox. His career batting average was .302 with 699 RBIs, and his best year came in 1930, batting .359 with 202 hits and 104 RBIs. Reynolds returned to Wharton after retiring in 1939 and served as an organizing trustee for the new junior college in 1946.

JOHN ROTEN

OREN FRAZIER

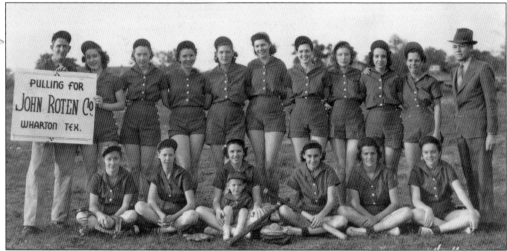

Women's sports have always been popular in Wharton, including championship volleyball teams at the high school and the junior college. Mercantilist John Roten, whose family proudly claimed ancestry to Commodore Matthew Perry, sponsored women's teams during and after World War II that traveled all across Southeast Texas to entertain crowds and encourage women's participation in team sports.

BILLIE JOE HALE

James E. Chase (1914–1987) served as mayor of Spokane, Washington. Chase was born and raised in Wharton, moved with several friends to the northwest to seek employment during the Great Depression, owned and operated a successful auto repair shop in Spokane, and there became involved in the NAACP and local politics. He married Eleanor Barrow in 1942, served on the city council, and became the city's first African American mayor from 1981 to 1985.

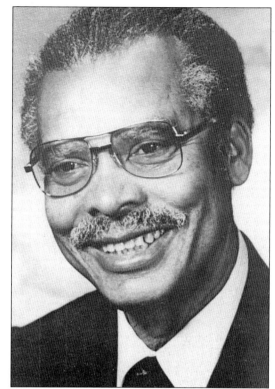

John M. Hodges (1885–1962) arrived in Wharton in 1915 to become the new public school superintendent. He returned in 1946 as the first president of Wharton County Junior College, where he served until his death. Hodges is credited with enormous advances in the public school system during his tenure and for the remarkable leadership he brought to the junior college, where his name today adorns the learning center and library complex.

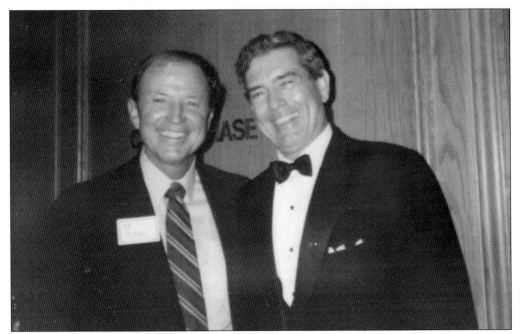

Dan Rather and his Wharton friend Doc Blakeley attended a Huntsville banquet together in 1989. A reporter and news anchor for CBS during the turbulent 1960s and 1970s, Dan Rather is a Wharton native who often returns to Texas for commemorative events and to speak to students at the junior college. Rather first appeared on national television with his dramatic reporting of Hurricane Carla from the teeth of the storm when it struck Galveston in 1961.

Playwright and screenwriter Horton Foote (1916–2009), born and raised in Wharton, aspired to act and made it to New York City, where he soon found his gifts for writing award-winning television and Broadway scripts. He won an Academy Award for his work on *To Kill A Mockingbird* and again for *Tender Mercies*, a Pulitzer in 1995, and Emmy Awards for the plays that depicted small town America in the imaginary Harrison, Texas, based largely on his own life in Wharton.

The administration building of Wharton County Junior College stood out at the edge of Wharton in the 1950s. Conceived by the Wharton Postwar Planning Board to bring higher education to the Bay Prairie, the junior college was chartered in 1946. During its estimable seven decades since, it has added a dozen buildings to its main campus on Boling Highway and expanded in the region to serve 65 high schools with additional campuses in Richmond, Sugar Land, and Bay City.

The Tee Pee Courts and Motel, pictured here in the 1960s, were built in 1947, renovated in 2007, and still serve tourists who travel through the Bay Prairie region. A "welcome to Wharton" atmosphere remains the signature of the small town that continues to beckon passersby, prospective residents, college students, and energetic new businesses.

BUILT IN 1947 ??

www.arcadiapublishing.com

MAP SEARCH

Discover books about the town where you grew up, the cities where your friends and families live, the town where your parents met, or even that retirement spot you've been dreaming about. Our Web site provides history lovers with exclusive deals, advanced notification about new titles, e-mail alerts of author events, and much more.

MADE IN THE
 USA

Arcadia Publishing, the leading local history publisher in the United States, is committed to making history accessible and meaningful through publishing books that celebrate and preserve the heritage of America's people and places. Consistent with our mission to preserve history on a local level, this book was printed in South Carolina on American-made paper and manufactured entirely in the United States.

Find Your Place in History.